62 LESSONS

BASICS

CHARACTERS

SPECIAL EFFECTS

DRAW CHIBI STYLE

A BEGINNER'S STEP-BY-STEP GUIDE FOR DRAWING ADORABLE MINIS

PIUUVY

QUARRY

CONTENTS

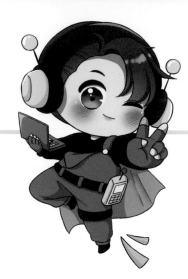

INTRODUCTION

I've been interested in drawing since I was a child. While my drawing abilities have always compared favorably to those of my peers, I decided not to study drawing, and my current focus of education is completely unrelated to art. However, I've maintained the inspiration and motivation to pursue art as a passion.

I chose chibi as my subject because I simply love everything "small and cute," which may also be the reason you're interested in learning to draw them. Chibi may look very simple at first, but once you've mastered basic drawing skills and are ready to invest some time in your artwork, you'll see that they can also become sophisticated works of art.

As you can see by looking through this book, my chibi style is influenced by manga and anime, plus a little bit of what I like. I know some of you will have trouble finding your drawing style. But that's okay! Don't put too much emphasis on it—it's completely fine if you start drawing by following my steps and style. Once you've gotten some drawing experience, you'll naturally find a style that you like and can settle into that reflects your ideas. Don't be disappointed if you're a beginner and your work isn't what you hoped it would be—if you make time to practice, your skills will improve.

HOW TO USE THIS BOOK

Draw Chibi Style is divided into two parts:

Chibi Essentials presents eighteen step-by-step tutorials, from building the body to facial expressions, clothing, and coloring. Spend time practicing each of these lessons to prepare to create characters.

Chibi Characters, Step-by-Step shows how to draw forty-four chibi characters from rough sketch lines to final color. You can use my characters and their wide variety of themes, poses, expressions, and details as a visual reference for creating your own characters, from fantasy to contemporary.

You can use this book for drawing with either traditional mediums on paper or working digitally. For traditional drawing, you'll need paper, an HB pencil for sketching, a 2B pencil for tracing the main strokes, an eraser, and a marker pen for inking, plus colored pencils, watercolors, or markers for coloring your character. If you prefer digital art, you'll need a tablet with a stylus and compatible software, such as an iPad with an Apple Pencil and Procreate or a Wacom Pen Tablet with a Bamboo Ink Stylus and MediBang Paint or Clip Studio Paint. Of course, you'll first need to spend some time familiarizing yourself with the software and getting used to working with the tablet and stylus.

I wish you all the best in your art journey. The more you practice and learn, the better your drawings will become—that's the most important thing.

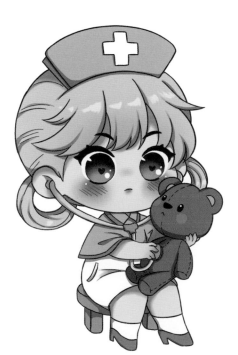

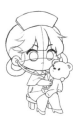
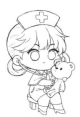

THE DRAWING PROCESS, STEP-BY-STEP

The first step after defining your overall character is to start sketching out your ideas on paper or with a digital drawing tool.

Sketching is an important step, almost indispensable, whether you've mastered it or not. It will help you visualize what your character is doing and what it looks like.

You start with the head and then add the chibi character body.

Note: Don't focus too much on details, such as clothes, hair, and eyes, at this step. Just concentrate on drawing the head, body, arms and legs, and hands and feet.

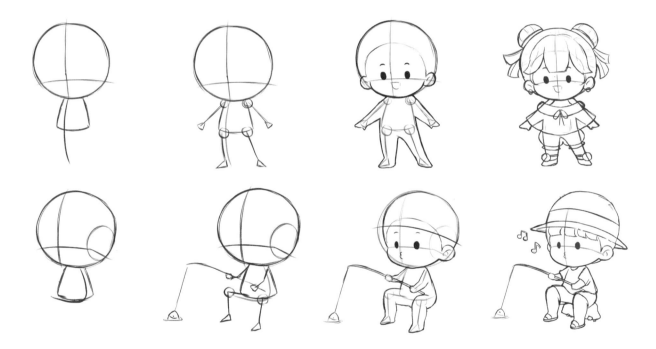

Once the basic shape is completed, begin sketching the details, such as the hair, clothing, eyes, mouth, and so on.

Make sure to pay special attention to the hair. Determine the hair style and hair direction first and simply sketch it out instead of attempting to draw individual hairs. For more on drawing hair styles, see page 30.

For the clothing, begin by drawing the overall silhouette of the outfit. For example, draw the shape of the T-shirt first, instead of focusing on drawing a pattern or other details on the T-shirt. For a dress, you should draw the general form of the dress instead of focusing on the pleats, buttons, lace, and other particulars. See page 32 for more information on drawing clothing.

LINE ART

Start drawing the outlines after completing the character sketch.

BASE COLOR

The goal is to find the color you want and make sure it coordinates with your environment and doesn't look too dark or too light.

Add shading to the head and body and blush to the cheeks and lips. Then, you can add some white streaks to the hair for highlights and white dots on the cheeks to create a lovely, plump feeling.

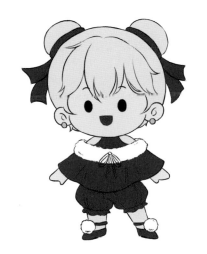 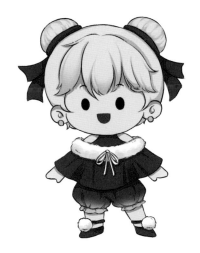

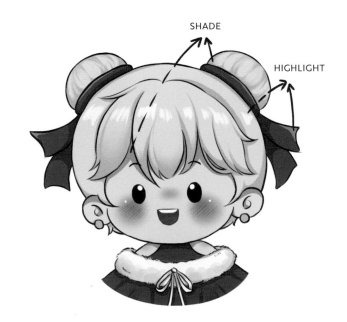

SHADE

HIGHLIGHT

UNDERSTANDING LINES

Line quality and clarity are important aspects when drawing chibi characters. In this lesson, I'll show you some tips for creating smooth, clean lines while sketching and inking.

SKETCH

This is a step that people often skip when practicing. But it's such an important stage in the chibi creation process that doing so can negatively affect the outcome of your chibi.

Your wrist and elbow should be in a comfortable position when sketching.

SKETCHING TIPS

Use light colors to sketch, such as red or blue (A), rather than dark colors, such as black. This pairs well with the softer colors typically used for chibi characters.

Drawing a line that's too thick and dark will make your sketch stiff and difficult to adjust, especially if you're drawing traditionally on paper. Drawing lines that are too bold can make it hard to see the details, and it will be a challenge to erase excess lines (B).

A sketch drawing should be light and relaxed (C). Using too much hand force makes the outline bold, rigid, and tough to modify. Sketch lines can be overlapped to form the right shapes and find the correct positions.

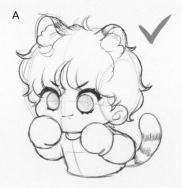
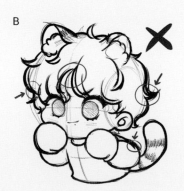
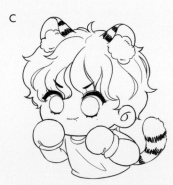

LINE WORK

How you use your wrist is very important. Keep it relaxed and use smooth, steady pressure to draw your lines as long as possible. Short, choppy strokes and overly strong wrist pressure will cause the line art to be shaky and distorted.

Drawing small lines and then joining them will result in disjointed lines, not fluid, seamless lines.

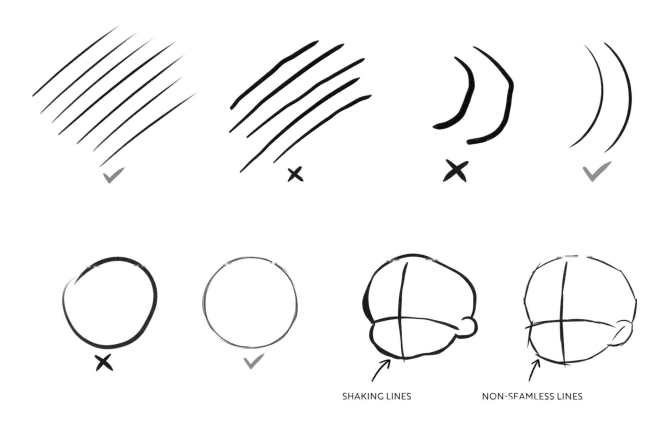

SHAKING LINES NON-SEAMLESS LINES

ONE-MINUTE PRACTICE: CIRCLES AND LINES

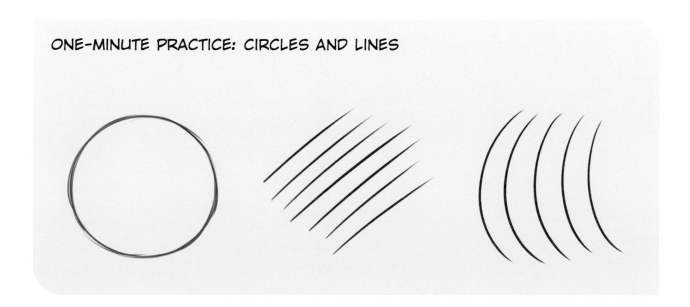

CHIBI FIGURES: PROPORTIONS

In this lesson I share the proportions I typically use in my daily chibi drawing. Chibi can be drawn in many different ways because the body ratios are very flexible.

AVERAGE CHIBI (2 HEADS HIGH)

I use this proportion most often because it looks cute and is just tall enough to be able to include many poses and clothing details.

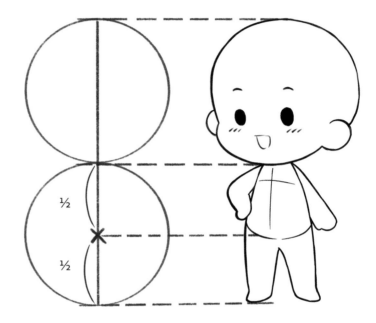

TALLER CHIBI (2½ HEADS HIGH)

This proportion will make for a taller chibi. If you like, you can use the taller proportion for male characters and the average proportion for female characters.

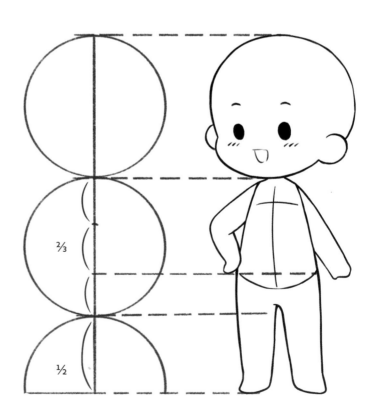

SEMI-CHIBI (3 HEADS HIGH)

I often use this proportion to show complex movements or outfits with many details while still maintaining the "lovely roundness" of the chibi.

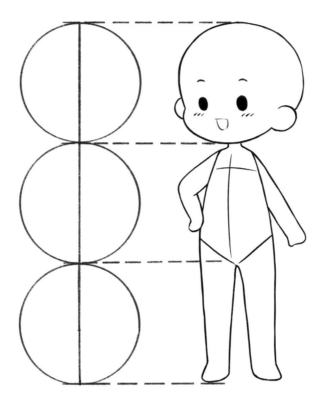

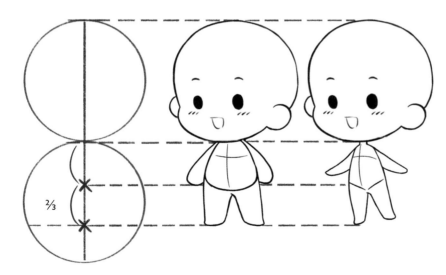

SMALL CHIBI (CHUBBY OR SKINNY)

If you want your chibi to look really tiny and supercute, this is your best option. You can hold them in the palm of your hand or put them in your pocket. This chibi is best suited for simple movements.

PROPORTION TIPS

- In addition to the proportions shown in this lesson, you can draw a chibi body smaller, taller, or chubbier.
- The smaller the proportions, the more "tiny and cute" a chibi will look. With larger proportions, you have more options for poses and can include more details in the clothing.

BASIC CHIBI BODY TYPES

There are many chibi body varieties, so you can use your imagination and adjust the proportions to your taste.

The short, rounded torso shape and the simplified neck and shoulders are the traditional characteristics of chibi; however, you can still draw a neck and shoulders on many chibi bodies but just on a small scale.

A-SHAPED BODY

The shoulders and neck are connected, so the body looks like a capital letter A.

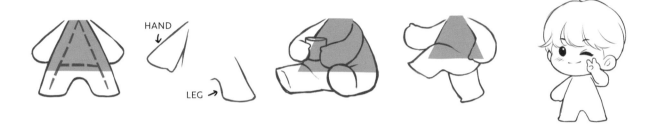

EGG-STAR BODY

The main shape of the egg-star body looks like an egg or a water drop. When the hands and feet are added, it looks like a star. It doesn't include a neck or shoulders. Small proportions and straightforward actions work well with this body type.

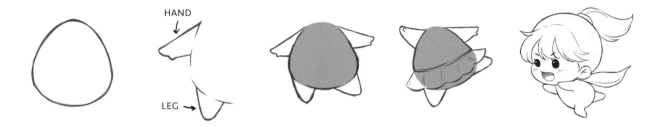

BEAN BODY

For this body type, picture the chibi as a bean. Then, add a head, arms, and legs to that bean.

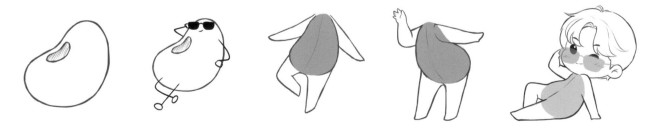

TRAPEZOID BODY

This body type is shaped like a trapezoid. This is the body type that I usually use. The shoulders and neck are optional.

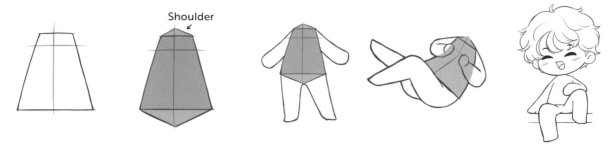

HOURGLASS BODY

Due to its two distinct sections, this body type has a slightly more complex structure.

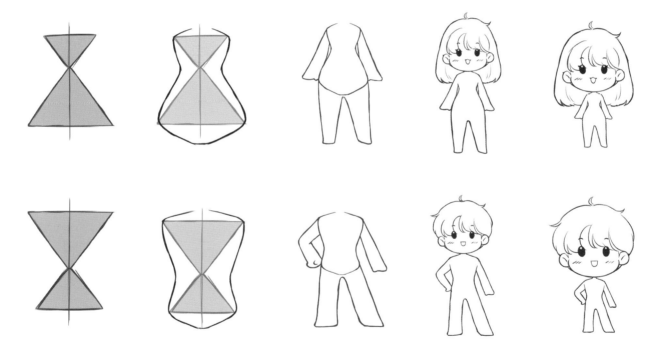

HOURGLASS BODY SHAPE TIPS

· Use two joined triangles to create the appearance of an hourglass.

· A female character's hips can be made to appear wider by drawing the lower triangle larger, which will also make her appear more charming and dynamic.

· A male character will have a larger top triangle, making the character's chest appear bigger and stronger.

BUILDING LINES OF ACTION

The easiest way to picture a character's activities is via a line of action, which can be described as an imaginary curved line that moves in a specific direction.

Here are some examples of lines of action:

Once the line of action is determined, all you need to do to enter the construction phase is to visualize the character's movement, which will give you enough information to build the body with respect to the character's activity more accurately.

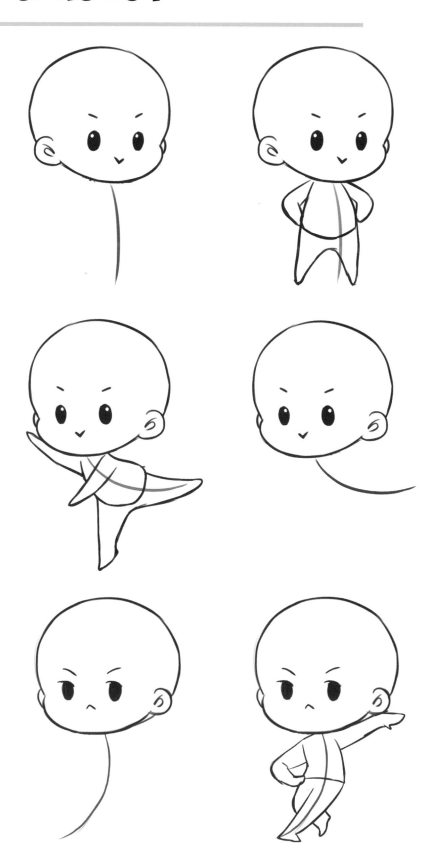

WHAT IS THE LINE OF ACTION?

- This might be regarded as the body's longest line.
- It can extend from head to toe, but when drawing chibi, I usually describe it from neck to toe.
- The line of action is employed to simplify the character's appearance and make it easier for you to picture how the body is moving.

If the line of action is identified and drawn first, followed by the body second, it will make the figure appear more alive, and the motions and gestures will look more natural. This also helps to balance your chibi.

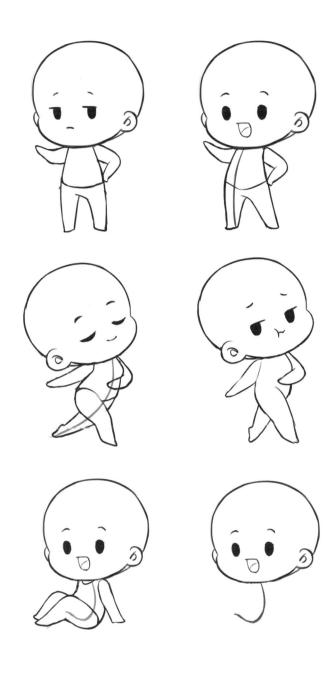

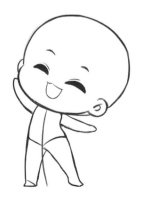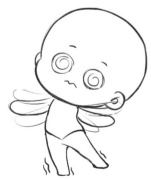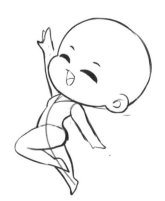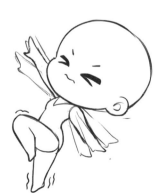

POSING YOUR CHIBI

Here are some basic structures you can use to learn how to construct and practice posing your chibi characters.

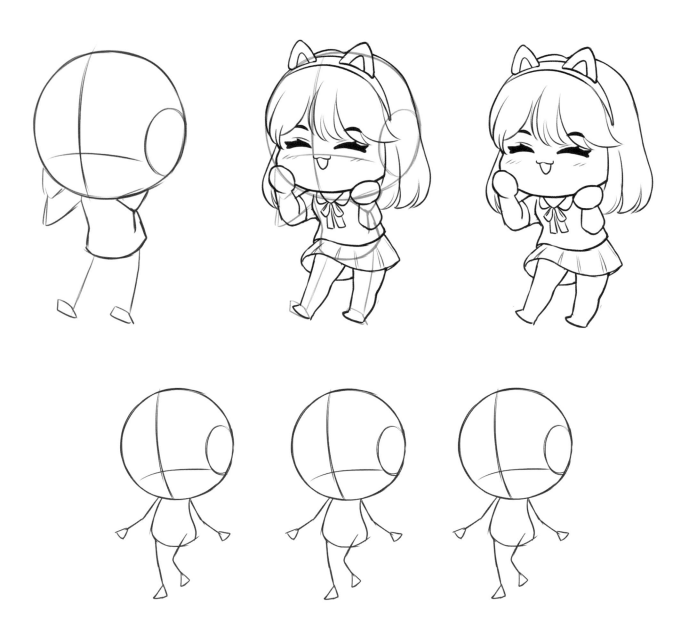

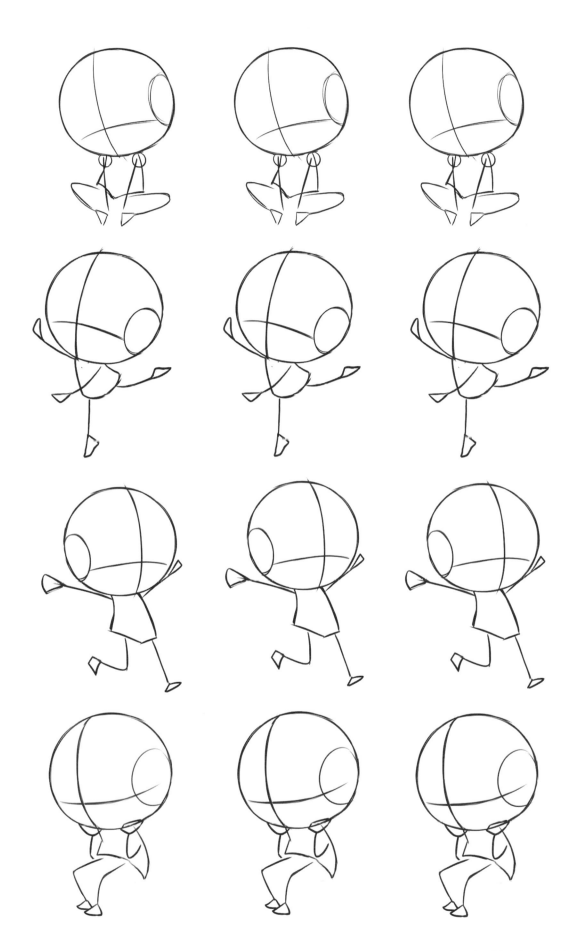

DRAWING CHIBI HEADS

One distinguishing characteristic of chibis is their large heads. In this lesson, I show how to establish the head proportions and how to position the head at different angles.

THIS IS A BALL

CUT A BALL

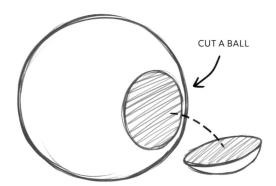

Cut off a small section of one side of the ball. Now, begin drawing the axial portion of the face. Picture a piece of string looping around the ball, down the middle vertically and about two-thirds of the way down horizontally.

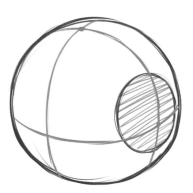

Consider drawing the head at several angles.

HAIRLINE

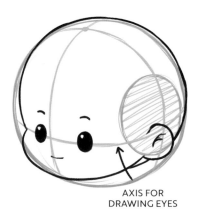

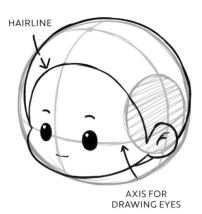

AXIS FOR
DRAWING EYES

AXIS FOR
DRAWING EYES

The angle of the face is established by the area where we cut the ball.

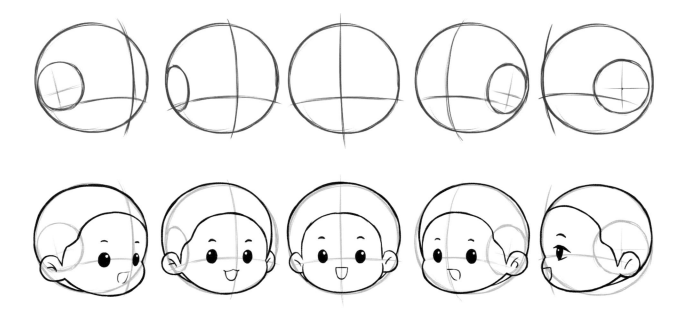

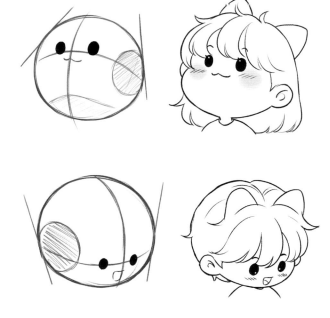

ONE-MINUTE PRACTICE: FACIAL ANGLES

Nothing beats practice, right? I'll sketch a few facial angles and examples for you to draw from. You can decide on the facial expressions for yourself. (Refer to "Facial Expressions," page 22, for some examples.)

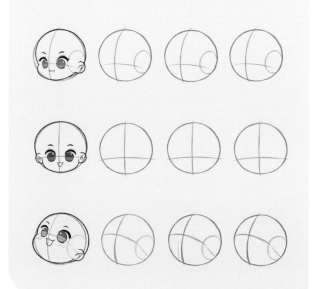

DRAWING CHIBI EYES

Like their heads, chibi eyes are also oversized, and they're also tremendously expressive. In this lesson, you'll learn the basic anatomy of the eyes as well as how to draw them at different angles and using various styles.

These are the basic features of the eyes. You must understand the most basic structures of the eye if you want to develop your eye drawing style.

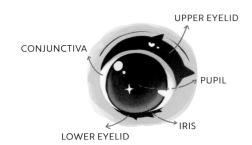

CONJUNCTIVA
UPPER EYELID
PUPIL
IRIS
LOWER EYELID

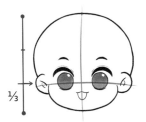
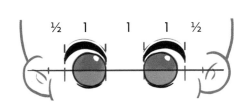
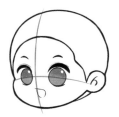

IT'S A BALL AGAIN
BUT DON'T CUT IT
WHITE OF THE EYE
LOOKING STRAIGHT
LOOKING UP
EYE DIRECTION
IRIS
LOOKING DOWN

Eyes are spherical.

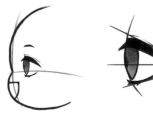

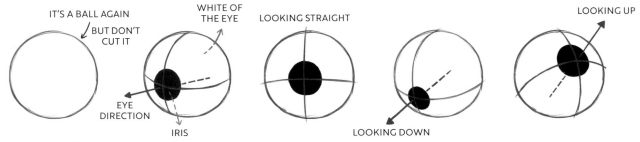

½ 1 1 1 ½

SMALLER BIGGER

Positioning the Eyes on the Face. Draw the forehead a little wider and the eyeline a little lower to give the character a sweeter, more innocent look.

The Ocular Axis at Various Angles. It should be noted that when you alter the angle of the face, the ratio of the eyes will also change. So, if you're unfamiliar with this detail, you should sketch the eye axis in a few different ways.

Three-Quarter View

Profile View

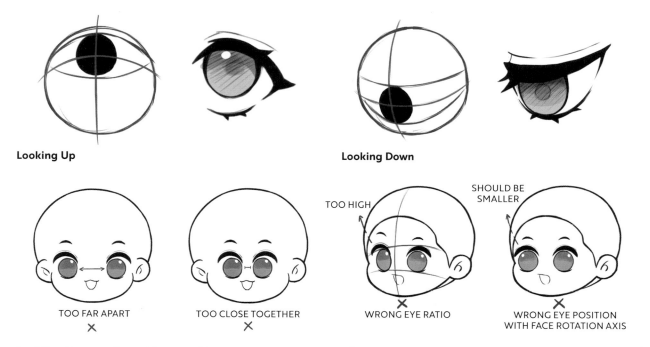

Looking Up

Looking Down

TOO HIGH

SHOULD BE SMALLER

TOO FAR APART
✗

TOO CLOSE TOGETHER
✗

WRONG EYE RATIO
✗

WRONG EYE POSITION
WITH FACE ROTATION AXIS
✗

Avoiding Common Errors. These problems are all associated with "the curse of the second eye." When placing the second eye, you may notice the following issues: the eyes aren't consistent, or they're too close together or far apart, or they aren't correctly aligned with the eye axis.

Male vs. Female Eyes. Typically, male eyes are simpler, with top lashes only and thicker brows. More of the eye itself is visible for females, which have top and bottom lashes and thinner brows.

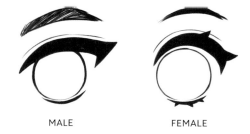

MALE

FEMALE

Tips for a Dramatic Iris. You can alter eye styles to your preference. The iris in particular is where you can get creative and mix colors for whatever shade you like. The iris should have a black pupil and a light color all around. You can add details such as a heart-shaped pupil, white circles, and stars for a dramatic effect.

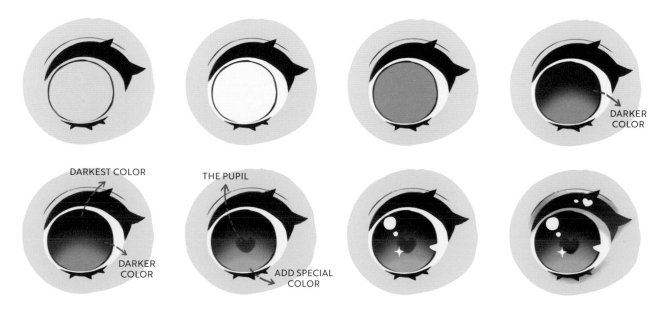

DARKER COLOR

DARKEST COLOR

DARKER COLOR

THE PUPIL

ADD SPECIAL COLOR

DRAWING CHIBI MOUTHS

Another notable characteristic of chibi are their graphic mouths. In this lesson, you'll learn how to create unique expressions for your chibi character's mouth by using suitable lines and multiple angles.

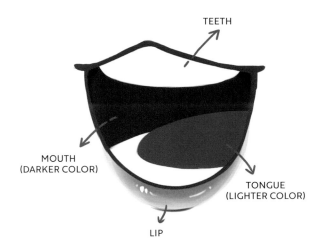

TEETH

MOUTH
(DARKER COLOR)

TONGUE
(LIGHTER COLOR)

LIP

AXIS OF THE FACE

To achieve the proper proportions and placement of the mouth, you must pay attention to the major axis of the face when designing it.

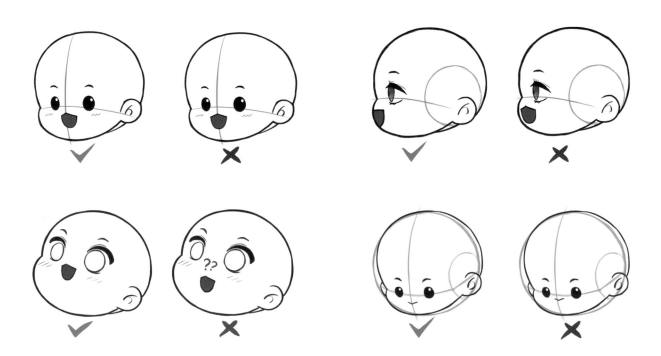

DRAWING TIPS

- **For digital art,** use a brush with an excellent gradation effect to soften the lips, such as an airbrush.
- **For traditional art,** a lighter layer of color should be applied to the lip, brushed evenly to create the most level foundation possible, and then a darker layer should be applied to the center of the lips.

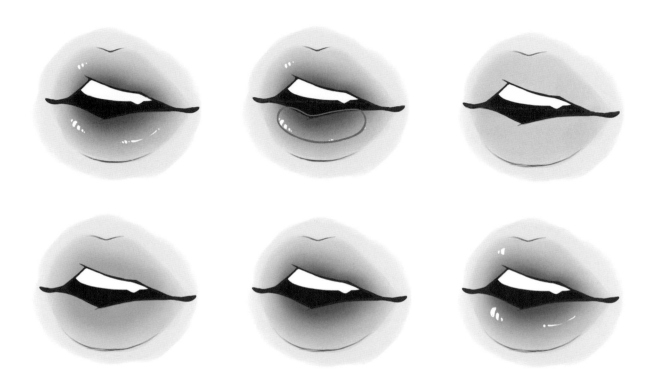

MOUTH EXAMPLES

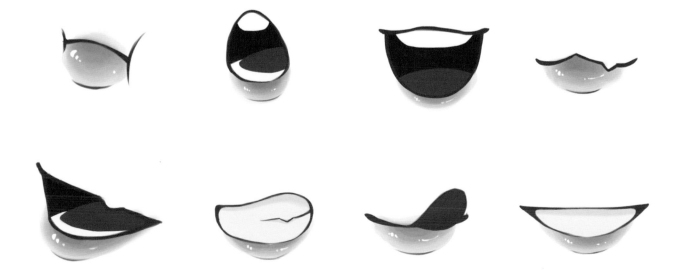

FACIAL EXPRESSIONS

Facial expressions can be varied simply by changing the direction and shape of the eyes, eyebrows, and mouth to show different emotions.

In this lesson, I show how the placement of the features along straight or lines curved either up or down can convey simple forms of expression. I also share ways on how to draw each feature to make your characters even more expressive.

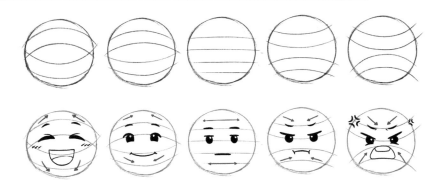

In general, upward-curving eyebrows indicate laughter, surprise, or satisfaction, while downward-curving brows express sadness or anger.

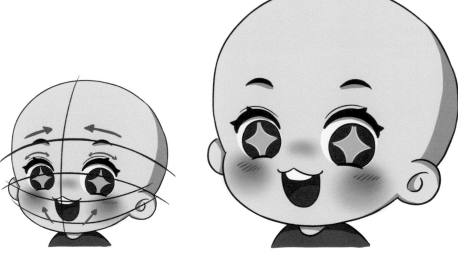

Surprised/Excited. The brows curve upward, the eyes sparkle brightly, and the energy of the mouth is buoyant.

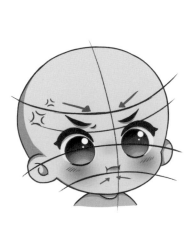

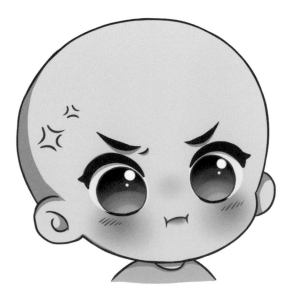

Angry. The brows curve downward and point toward the eyes, and the mouth is small and tightly drawn.

OTHER KEY EXPRESSIONS

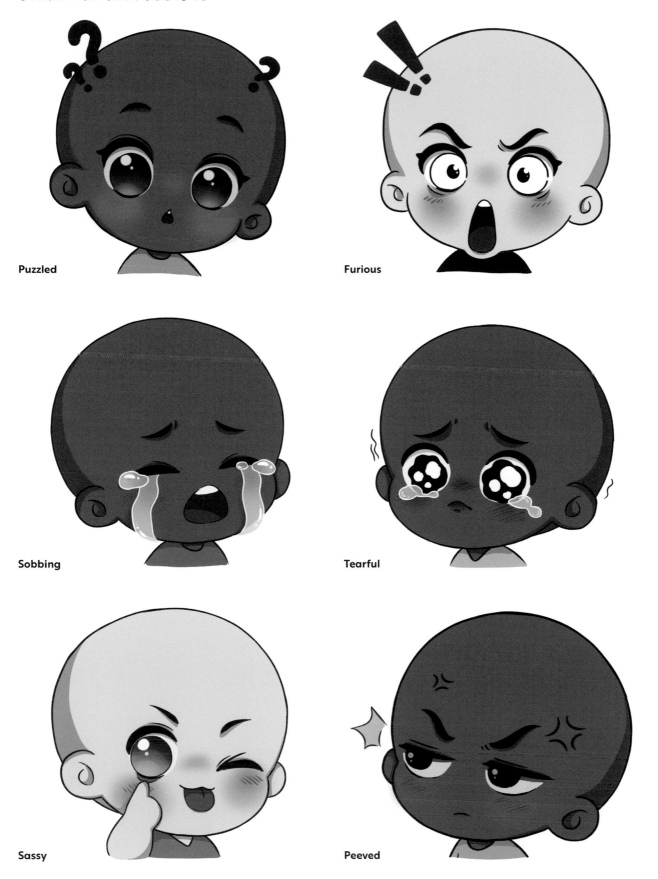

Puzzled

Furious

Sobbing

Tearful

Sassy

Peeved

DRAWING CHIBI HANDS

The basic structure of the hands is the palm, four fingers, the thumb, and the knuckles. In this lesson, I show how to easily create a simple hand that's perfect for whatever activity your chibi is performing.

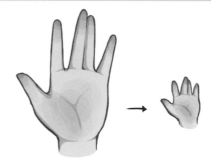

ANALYSIS OF SIMPLE HAND FORMS

The palm portion of the hand is shown in the images below.

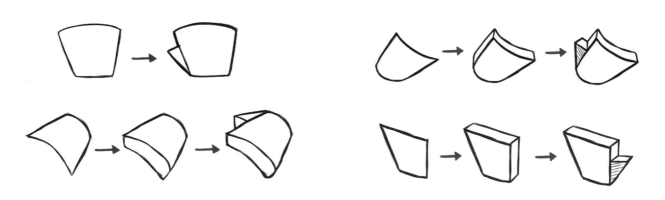

FINGERS AND KNUCKLES

Because the size of the chibi's hands is so small, drawing chibi hands with the fingers may sometimes be difficult. We need to simplify sketching them so we can focus more on how to draw the fingers.

If you lift your finger, you'll be able to see three knuckles. However, the chibi finger can be divided into only two sections if you don't need to portray the hands in great detail.

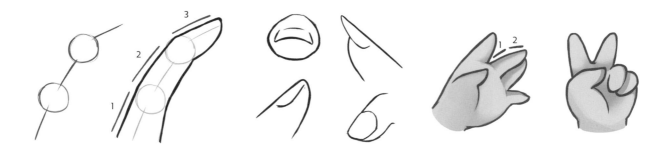

HAND CONSTRUCTION

Let's assemble the entire hand:

- Make the thumb slightly wider than the four other fingers.
- Add the fingers by drawing four lines perpendicular to the palm's axis.
- Draw the fingers using a straightforward and basic fingerlike shape.
- Make the knuckles on the chibi hand simple. There's no need to draw any details.

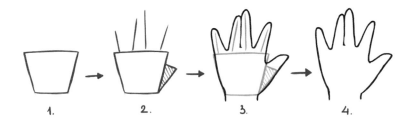

1. 2. 3. 4.

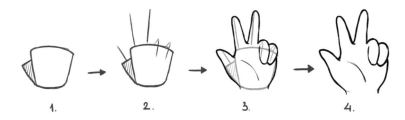

1. 2. 3. 4.

AVOIDING COMMON ERRORS

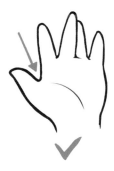 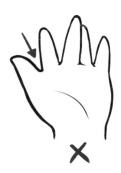 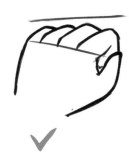 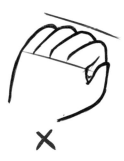

The joints of the fingers are different lengths, and the thumb should be lower than the other finger junctions.

Drawing the fingers from smallest to largest will make the hand more proportionate and natural-looking.

EXAMPLES OF HANDS

 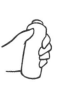 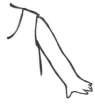

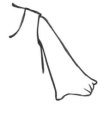

DRAWING CHIBI LEGS AND FEET

The basic structure of the leg has three main joints: the hip joint, the knee joint, and the ankle joint. In this lesson, I show a variety of options for positioning the legs of your chibi character.

STEPS FOR CREATING LEGS

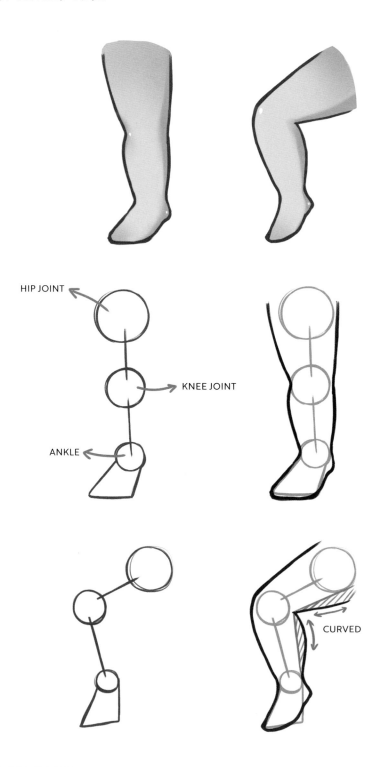

DRAWING FEET

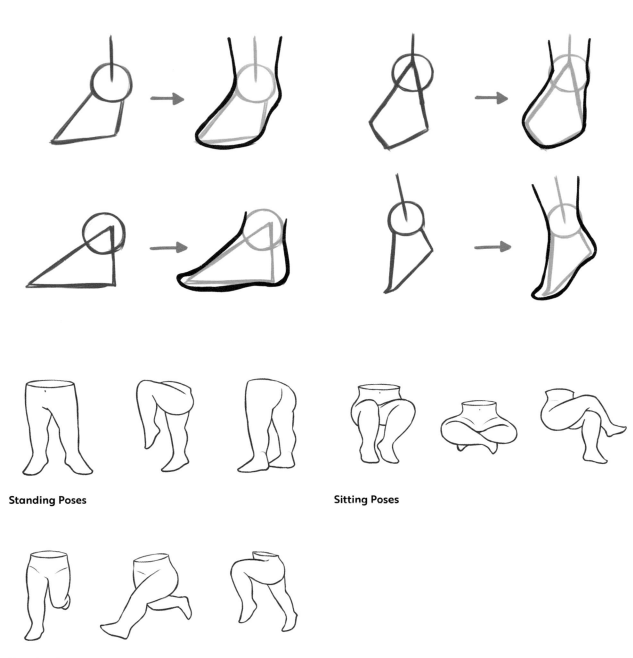

Standing Poses

Sitting Poses

Running Poses

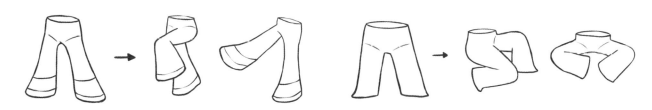

Poses with Clothing

HAIR FUNDAMENTALS

While it can sometimes be a challenging component, hair is interesting because of how fluid and free its movements are. That's why having lovely hair will make the character come alive.

Hair always has its structure, but if we're unfamiliar with the basics, we can quickly get lost trying to figure out which direction the hair is going. That will result in potentially difficult hair-drawing sessions and the occasional incorrect proportions, such as a head that's too high or hair that's too close to the skull.

STEPS FOR DRAWING HAIR

When drawing hair, be sure to use curved strokes to give it a delicate, flowing appearance. Add gaps, little curls, and baby hair to make it look more natural. Avoid drawing splits to break up lines and sketch continuous straight lines instead. When sketching the hairs, use a bold pen at the hairline and a lighter one elsewhere.

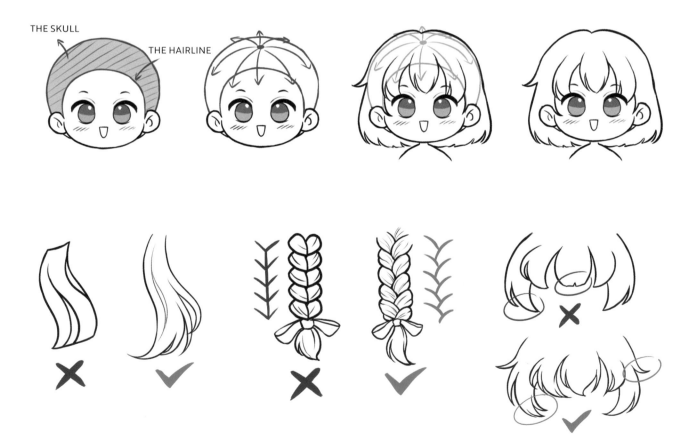

THE SKULL

THE HAIRLINE

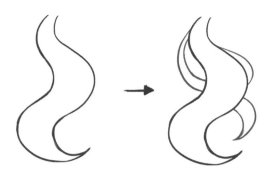
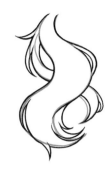
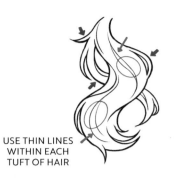

USE THIN LINES
WITHIN EACH
TUFT OF HAIR

MOVEMENT AND HAIR FLOW

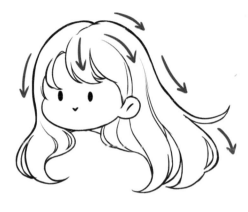
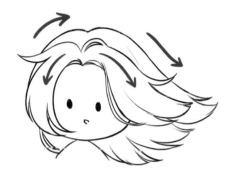

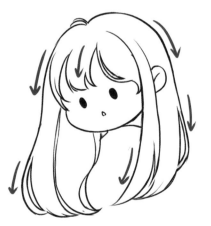
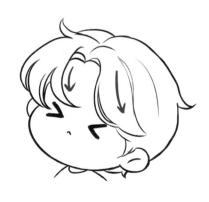

COMMON HAIR DRAWING MISTAKES AND SOLUTIONS

Instead of using scribbles to draw untidy strands, first decide the direction and style of the hair by drawing it in arrays or clumps.

TOO SMALL TOO BIG

EXAMPLES OF HAIR STYLES

Here is a collection of hair styles for your chibi characters.

LONGER STYLES

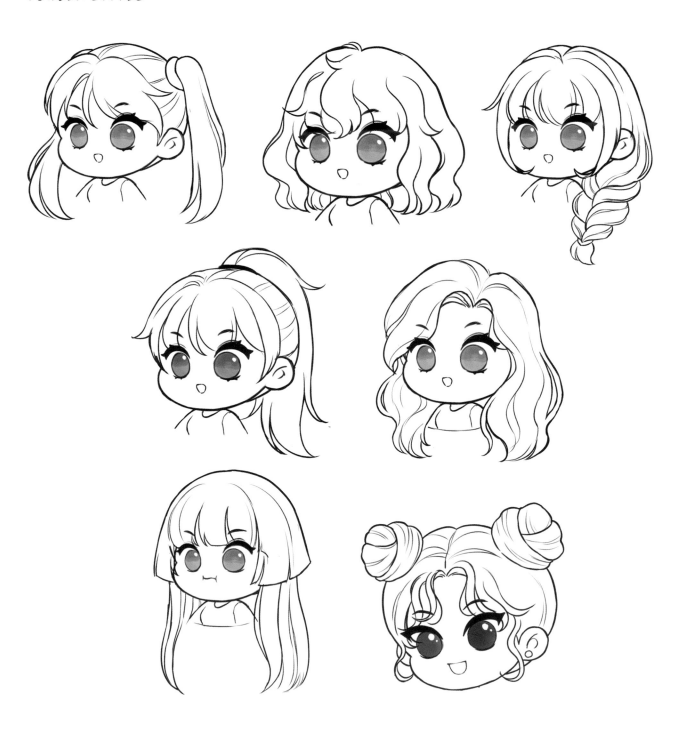

SHORTER STYLES

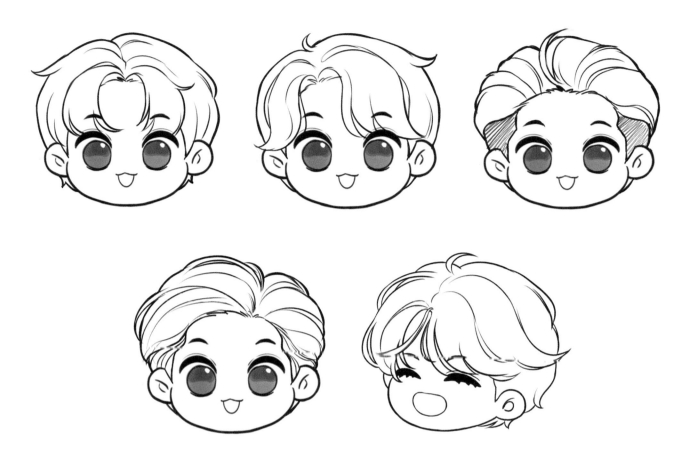

HOW CURLS WORK

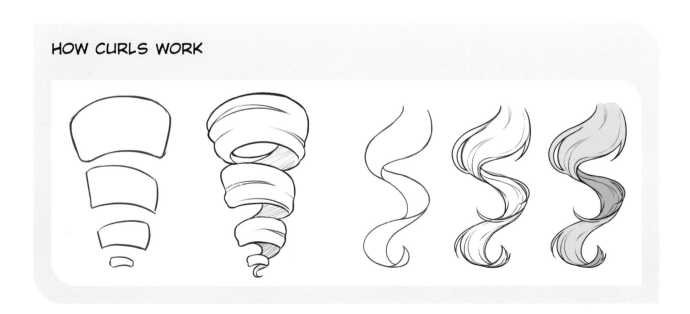

DRESS UP YOUR CHIBI

Here's a wardrobe of chibi-proportioned fashions, shown in various poses and from several perspectives.

 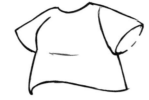 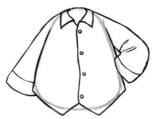 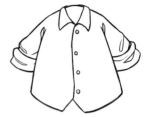

T-Shirt **Button-Down Shirt**

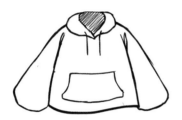 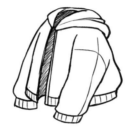 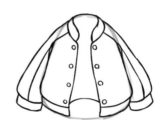 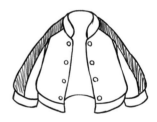

Hoodie **Baseball Jacket**

 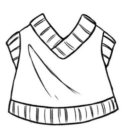 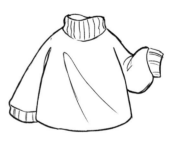

Puff Sleeve **Pullover Vest and Turtleneck**

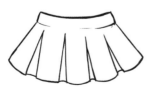 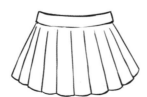 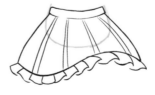 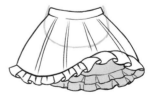

Pleated Skirts **Ruffled Skirts**

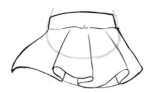

Flowing Skirts

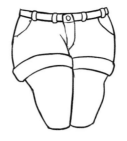
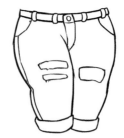
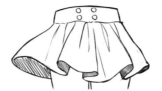

Jeans—Cutoffs and Cuffed

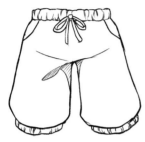

Sweatpants and Trousers

Officewear—Vest and Tie

MOVEMENT AND WRINKLES

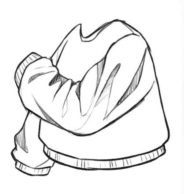

HEADGEAR

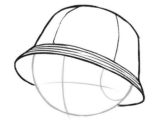
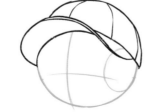
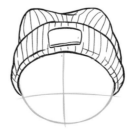
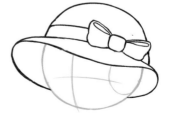

Bucket Hat and Baseball Cap

Wool Cap and Bonnet

FINAL LINE AND BASE COLOR

The base color you choose sets the tone for your chibi character. In this lesson, I share tips for creating a chibi that's harmonious, attractive, and most importantly, colorful!

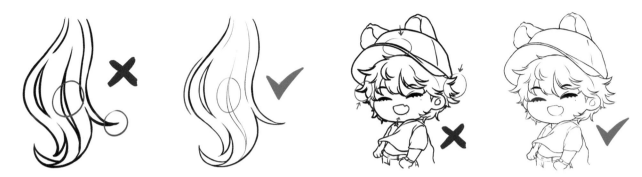

Final Line. Your character should be lined after being sketched. It will be simpler to view and recognize minute features with thin lines. For example, make the outer stroke a little thinner than the inner stroke for the strands of a curl or the folds of clothing.

Additionally, it's crucial to avoid using the same thick or thin stroke for every detail; instead, you should adjust the line's thickness or even switch between different brush types, depending on the task.

Base Color. Your character's base color serves as the first color layer you apply, giving you a general idea of the right color tone.

 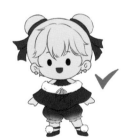

One of the easiest mistakes you're likely to make (one I've also made) is choosing an **intense base color** because you think it will make your character look brilliant. Using brash base colors like neon colors will give the chibi the impression of being too bright and will be irritating to the eyes. It will also prove to be challenging to pick the appropriate shading color.

The lower spectrum of color should also be avoided because it's too dark. You can't tell where the light and dark portions are; therefore, shading becomes a challenge, as well as trying to blend with other colors.

 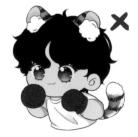 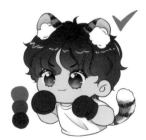

You shouldn't use **pure black** for chibi drawings. It's too strong and contrasts harshly with other colors. Dark purples or dark blues are better options and work in harmony with the softer color palette most often used for chibi characters.

COLOR COORDINATION TIPS

There are many ways to coordinate colors. Here I share some of my favorite tips with you. The following three established guidelines are simple to understand.

1. Analogous Color Combination.
This color scheme typically uses three adjacent colors on the color wheel. The total number of colors is flexible, but the number of main colors is always three.

2. Complementary Color Combination. This color scheme uses two colors that are opposite one another on the color wheel.

3. Triadic Color Combination.
This color scheme uses three colors on the color wheel that create an equilateral triangle. This technique is a little more sophisticated than the first two.

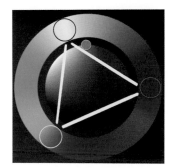

I hope some of my advice for choosing and combining colors for your chibi proves to be useful to you as you learn to draw. Keep in mind that as you create your chibi characters, you may sometimes need to recolor them, blend the colors, and adjust the brightness of the colors.

UNDERSTANDING LIGHT AND SHADOW

In this lesson, I show you how to give your chibi character dimension through value, which is the lightness or darkness of an object.

HOW LIGHT AFFECTS SHADOW

Although determining the direction of light can sometimes be a somewhat difficult task, it has a very distinct and vivid effect when applied to your character.

To add shading, reduce the overall brightness and the brightness of the colors by adding soft and hard shadows, following the direction of the light, and blending them, creating a three-dimensional look. The best approach to understand the practice of separating light and dark is to refer to as many realistic or creative photographs as possible.

Shown below are different directions of the light.

COLOR AND SHADING

It's important to note that choosing shade colors involves more than just picking darker hues. It's preferable to pair related tones together to make your art background or character appear more energetic and vibrant.

For example, for shading the skin color, it is recommended to add a little purple to the hue in the dark area. Absolutely do not use black for the shading—it's simply too stark. My personal preference is to shade the skin with a complementary color that's similar to the skin tone but a little darker so the skin appears more youthful. In this illustration, I put more orange for this skin shading.

Note the use of color in the red and blonde hair examples at left.

Instead of only adjusting the dark tone of the base color for the red hair, I decided to make the neighboring color somewhat pink (or possibly a bit purple).

I selected an adjacent hue with a stronger orange-red tint for the platinum blonde hair. If only a dark shade is used, the curl will appear harsh rather than gentle.

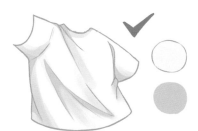 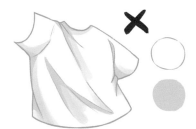

It should be mentioned that white is a unique hue as well. Instead of utilizing pure white, add a bit of color, such as blue or orange. In this case, I used light blue or light purple to represent white in order to avoid using a dark gray or black for the shading.

SPECIAL EFFECTS

In this lesson, I share some tips for special effects that will make your characters come alive on the page.

CHEEKS AND LIPS

For chibi's cheeks and lips, I often use an airbrush and two or three coats of color. Use a lighter color to indicate where the cheeks and lips should be, and then add a darker color to indicate the cheeks and inner part of the lips at the top.

Cheeks **Lips**

Adding Hightlights. To give cheeks a shiny appearance, add a white dot. In addition you can apply some slanting or horizontal streaks on the cheeks using a little darker color, which typically conveys shyness or tipsiness. Light white streaks added to the lips will also make them appear fuller.

Cheeks

 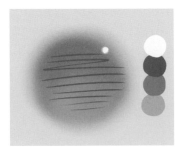 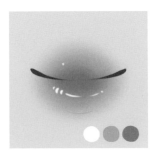

Cheeks **Lips**

HAIR

The bright streak effect gives the hair a more vibrant appearance. Simple representations of hair reflections can be done in a variety of ways.

A note about the hair highlight color: I use blue to highlight blonde hair, which is the opposite color from yellow on the color wheel. I could also use neighboring colors like red or orange. This is the color scheme I typically choose, but you also need to consider the color of the light source. Also, remember that you shouldn't use pure white for the highlights.

Here I've added a few optional tiny stars to create the sparkling effect. Feel free to remove or rearrange these.

SPECIAL HIGHLIGHTS

When you want to highlight the sunlight or if you want the spotlight to be more prominent, add in more light streaks. You can do this by adding in layers, or for digital drawings, you can use the color dodge effect.

NHAT BINH TRADITIONAL VIETNAMESE BRIDE

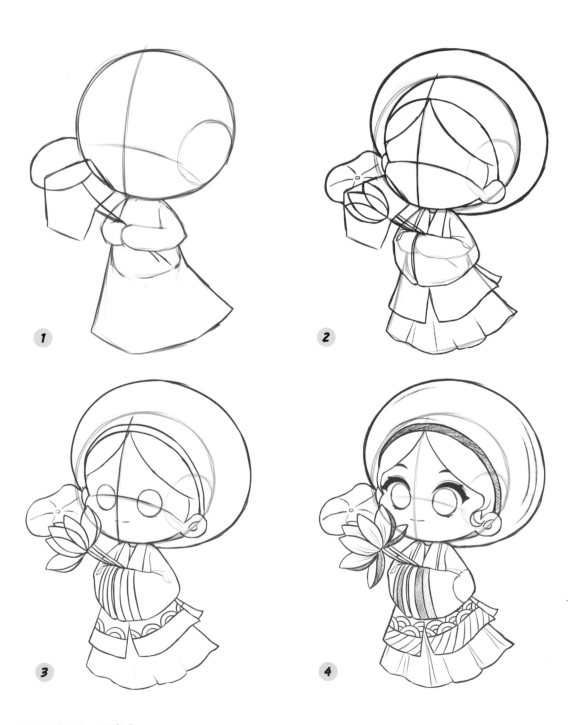

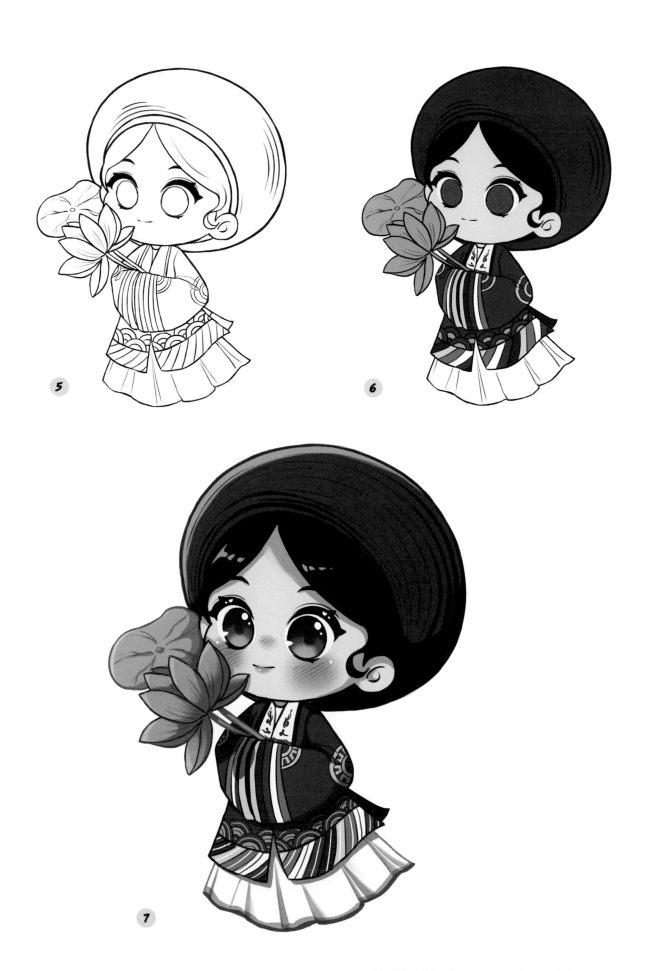

5

6

7

KOREAN GIRL IN A CHUSEOK

1

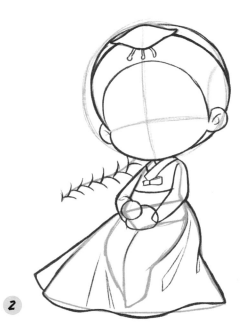

2

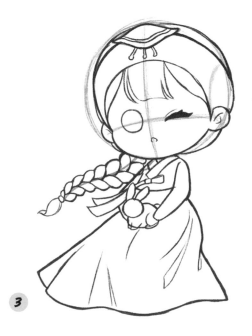

3

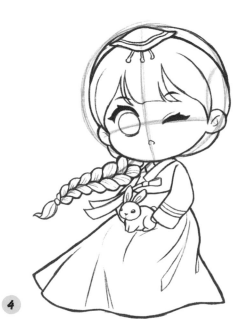

4

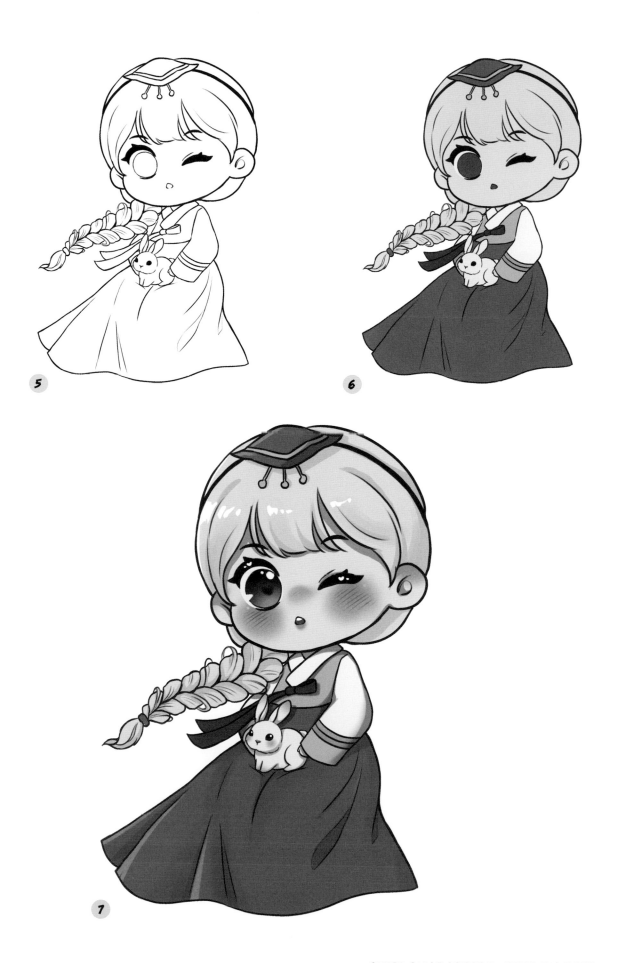

5

6

7

SAKURA WITH KIMONO

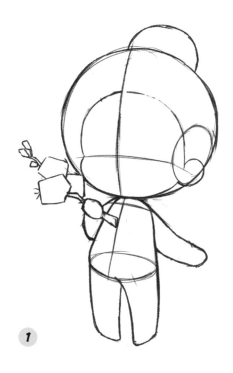

1

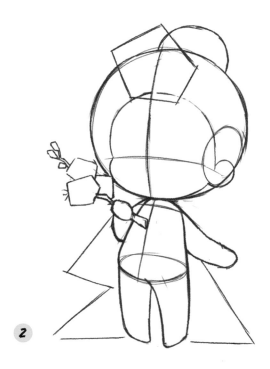

2

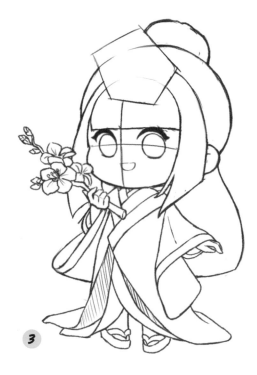

3

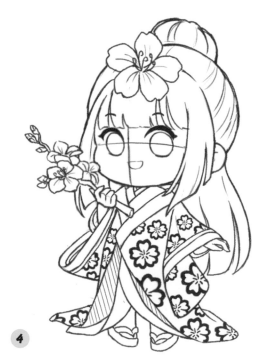

4

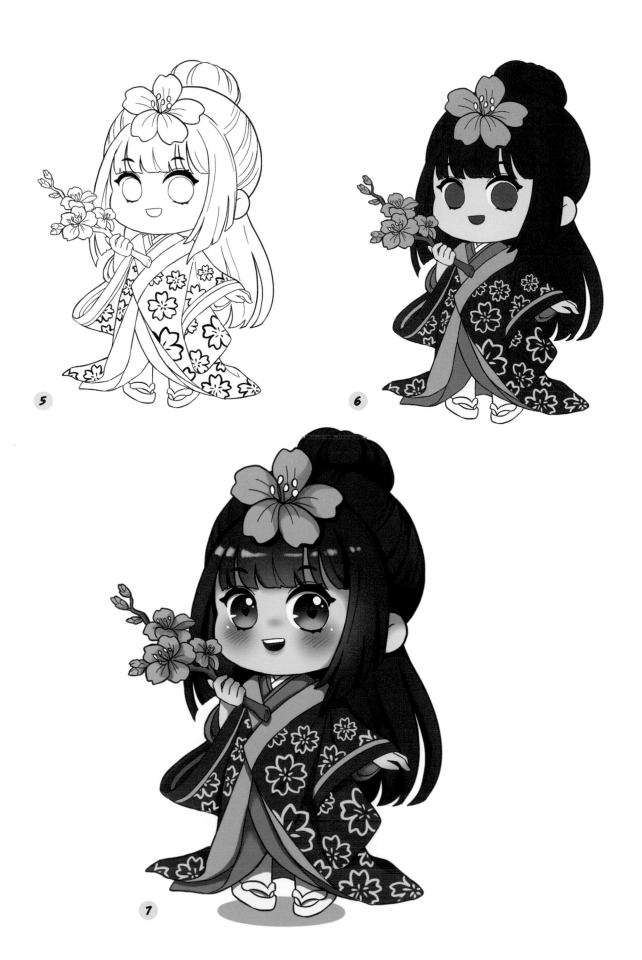

5

6

7

QIPAO FESTIVAL GIRL

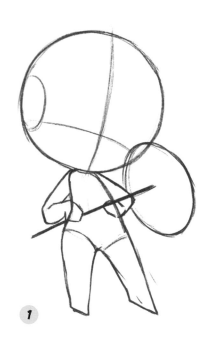

1

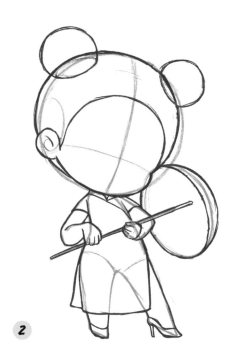

2

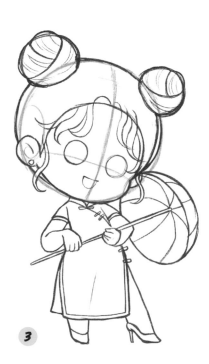

3

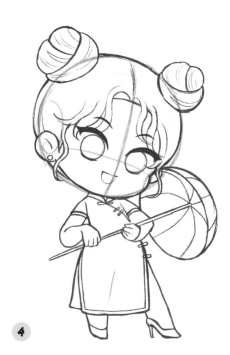

4

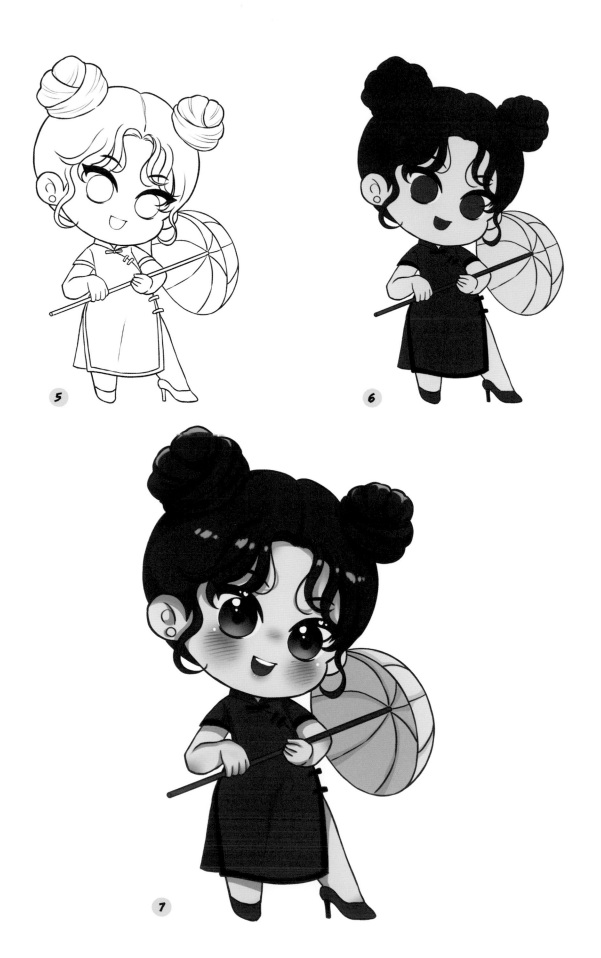

5

6

7

HALLOWEEN "TRICK OR TREAT"

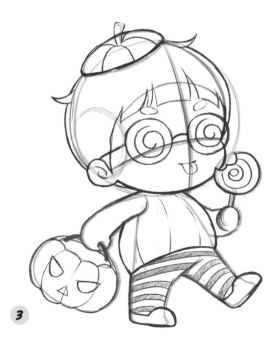

1

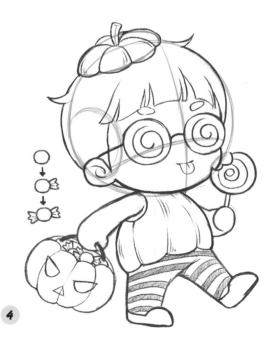

2

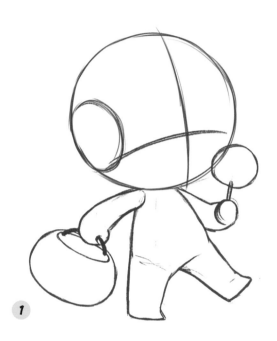

3

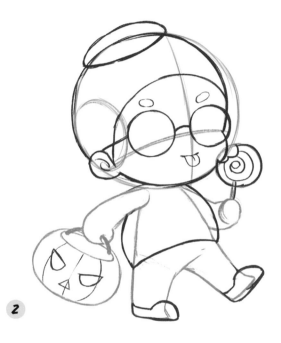

4

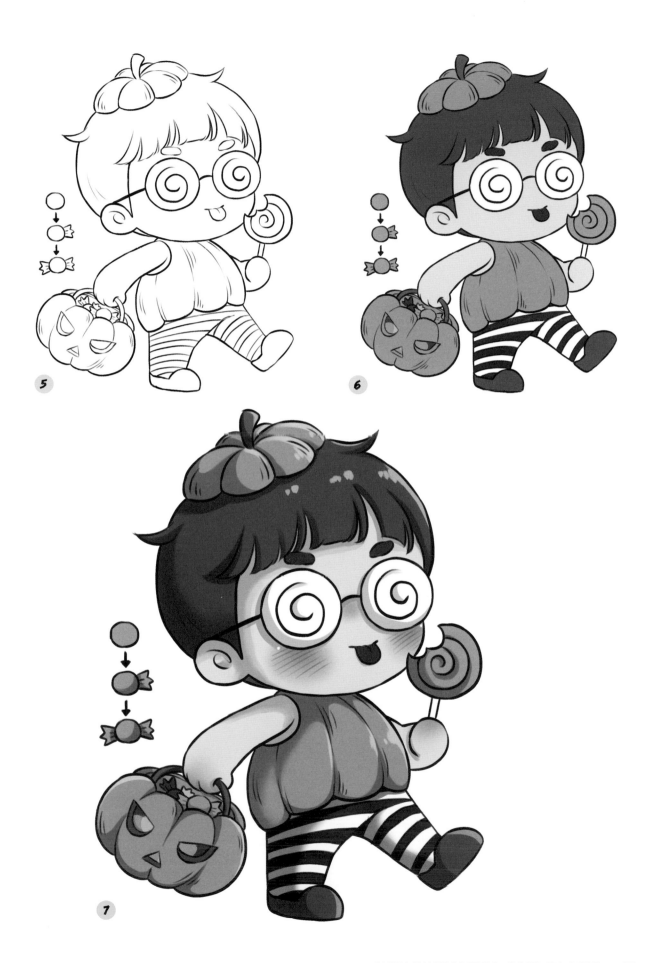

"LION DANCE"

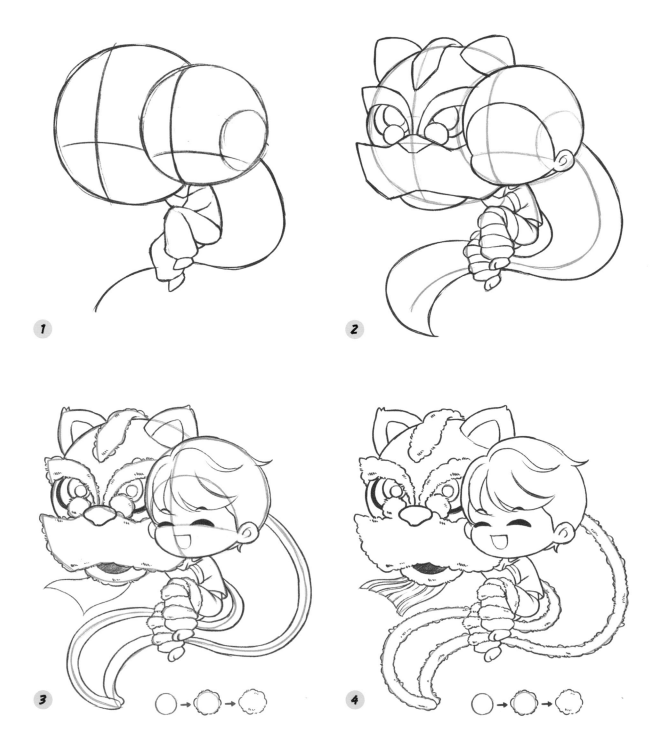

1

2

3

4

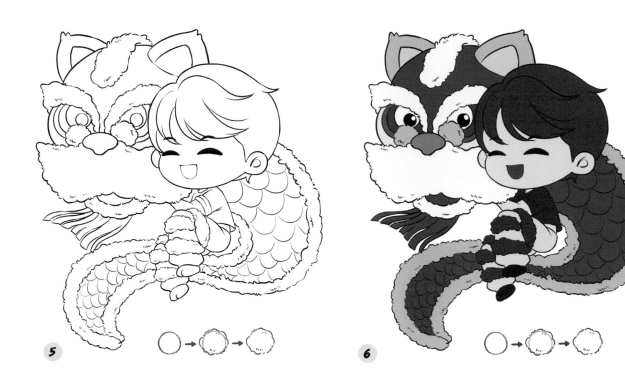

5

6

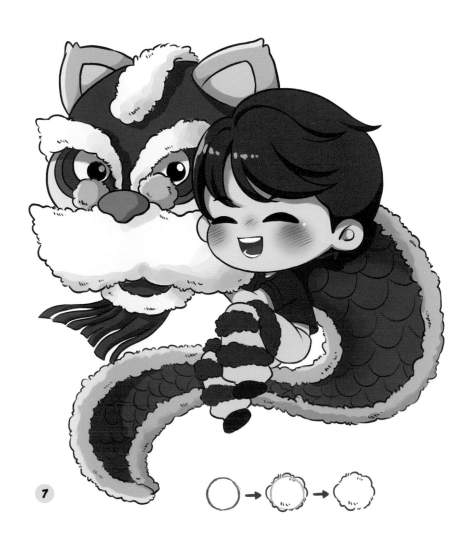

7

LITTLE MERMAID

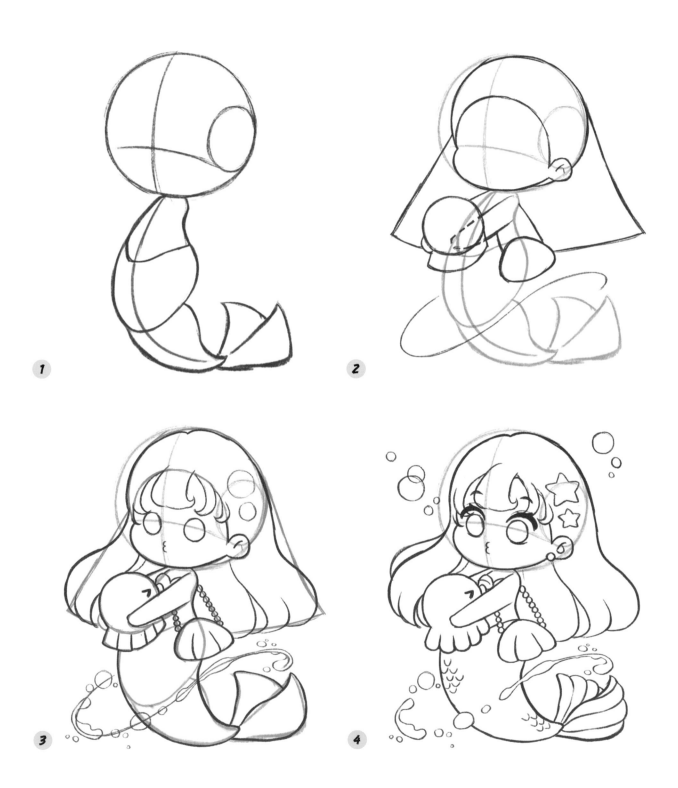

1

2

3

4

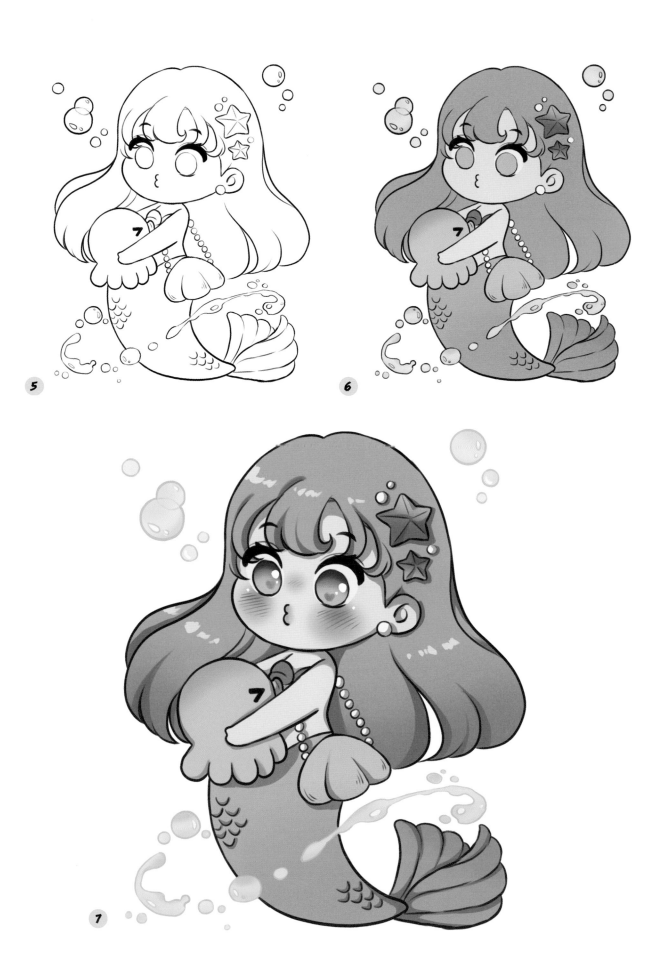

BABY WITCH

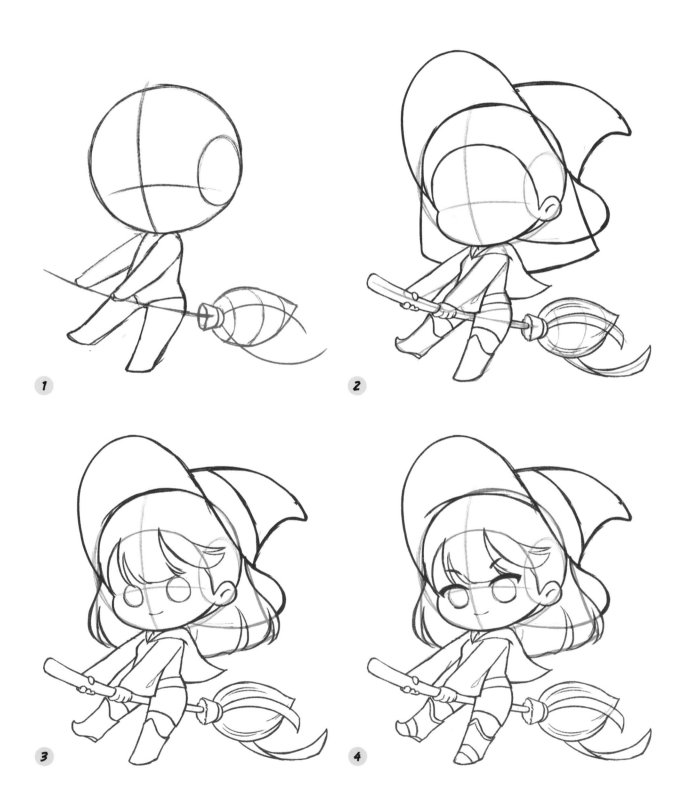

1

2

3

4

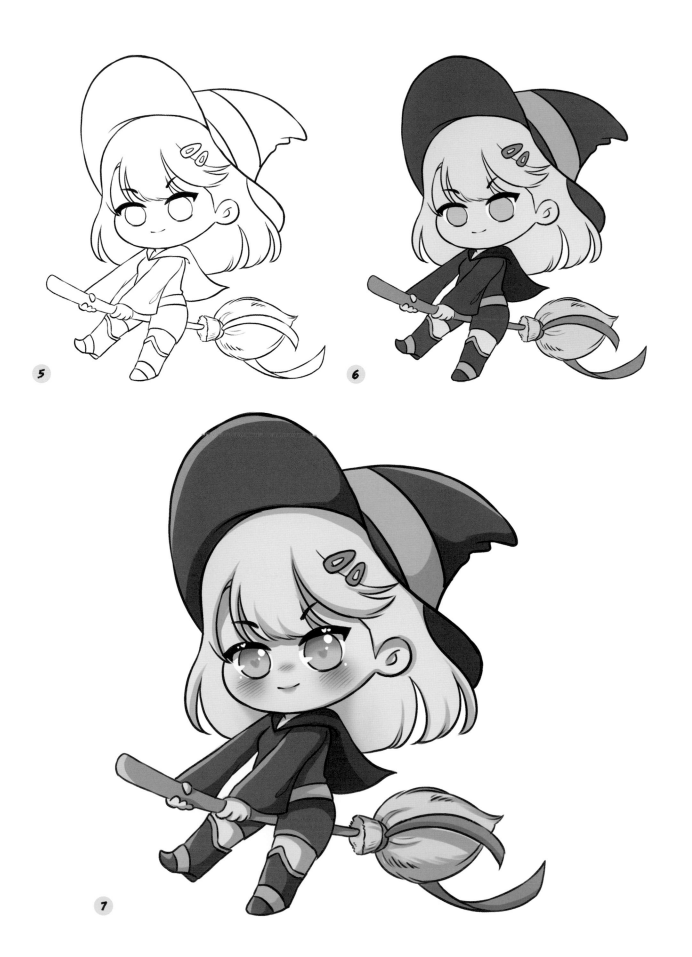

FIRE WARRIOR

1

2

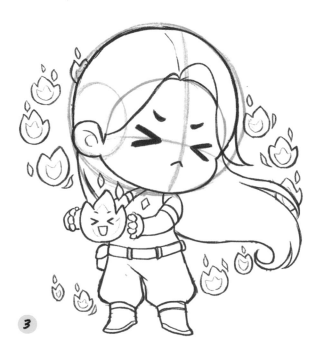

3

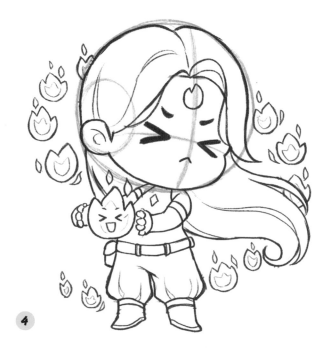

4

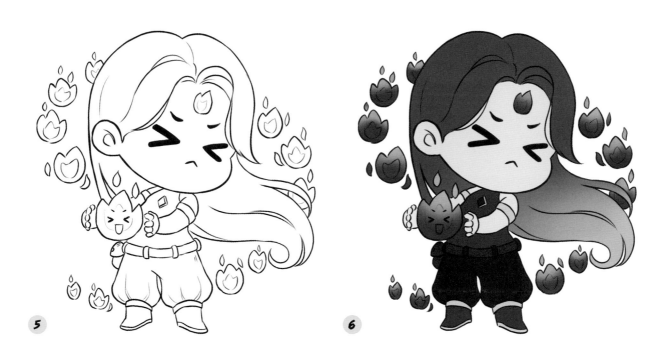

5

6

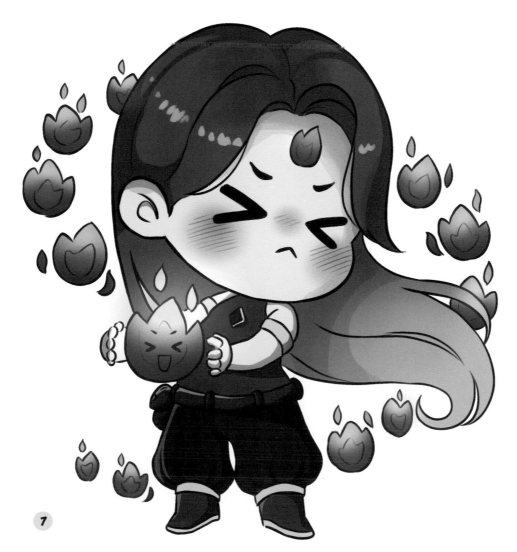

7

CUTE GOBLIN

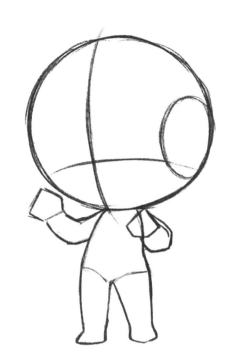

1

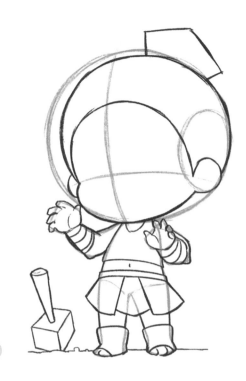

2

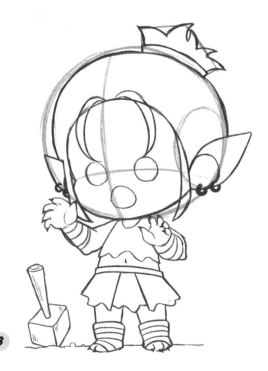

3

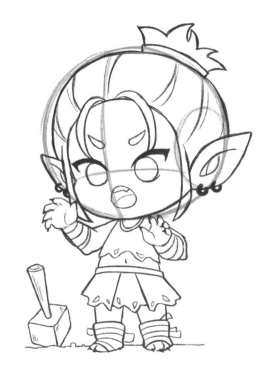

4

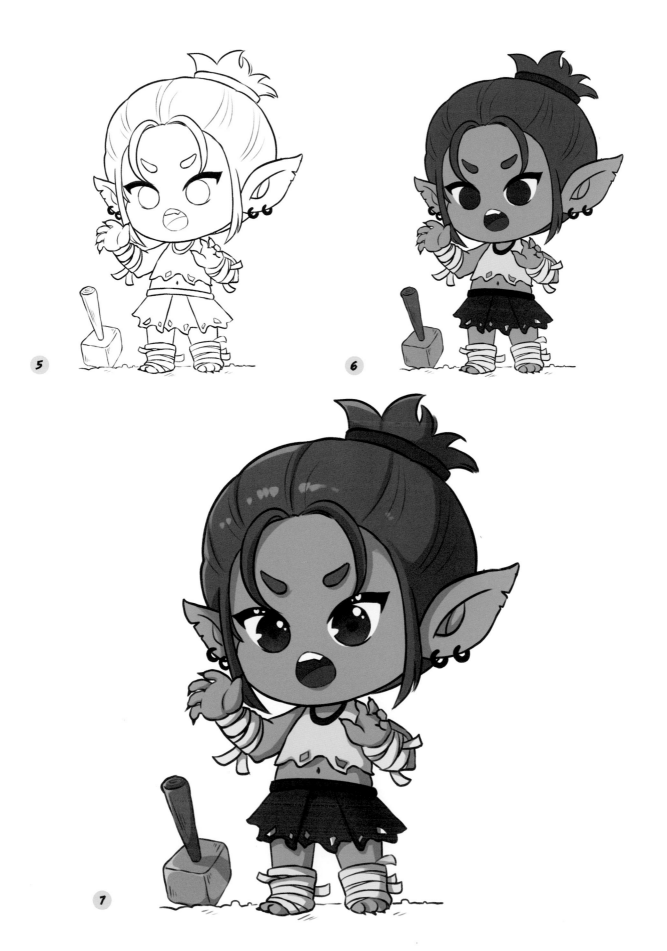

5

6

7

LAB RESEARCHER

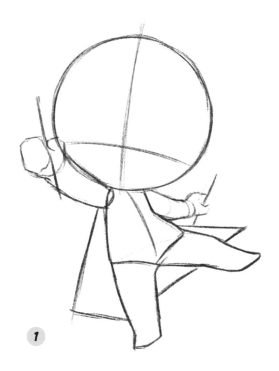

1

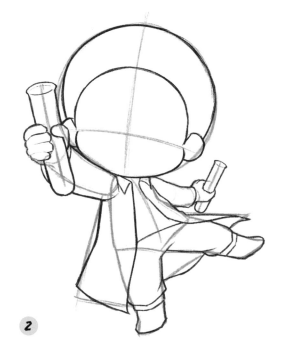

3

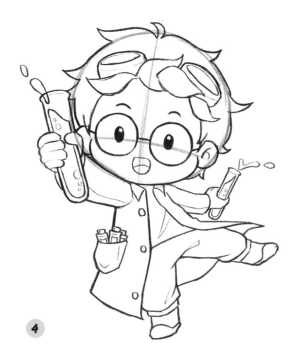

2

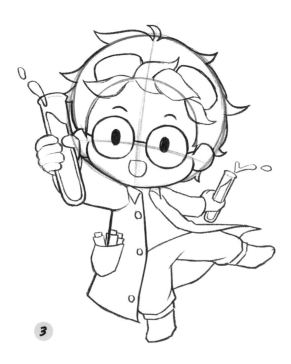

4

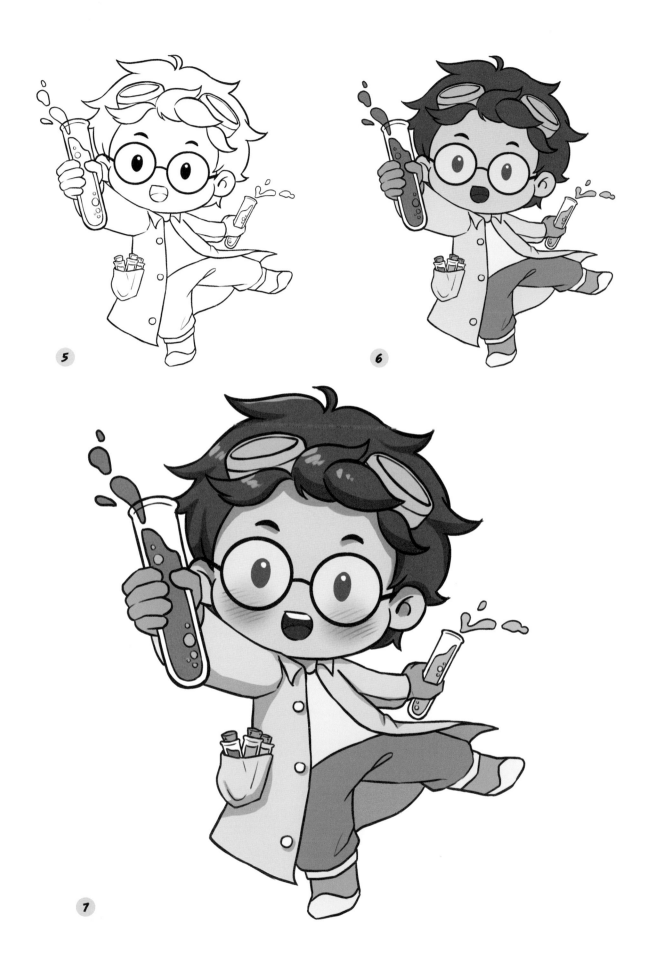

5

6

7

BUTTERFLY FAIRY

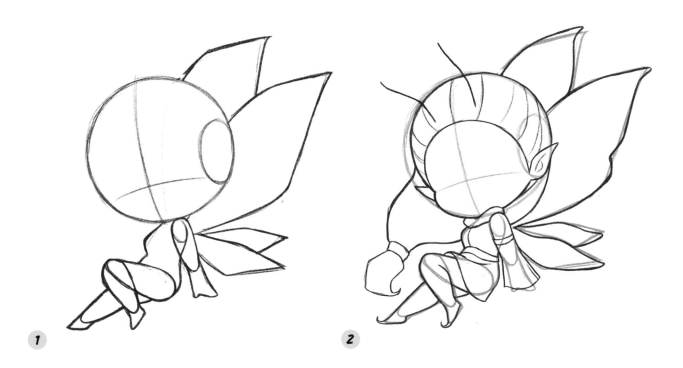

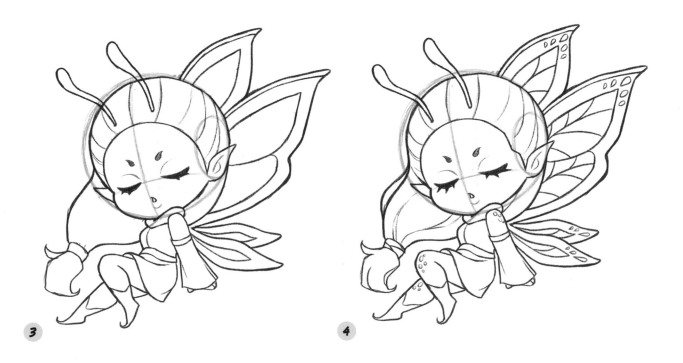

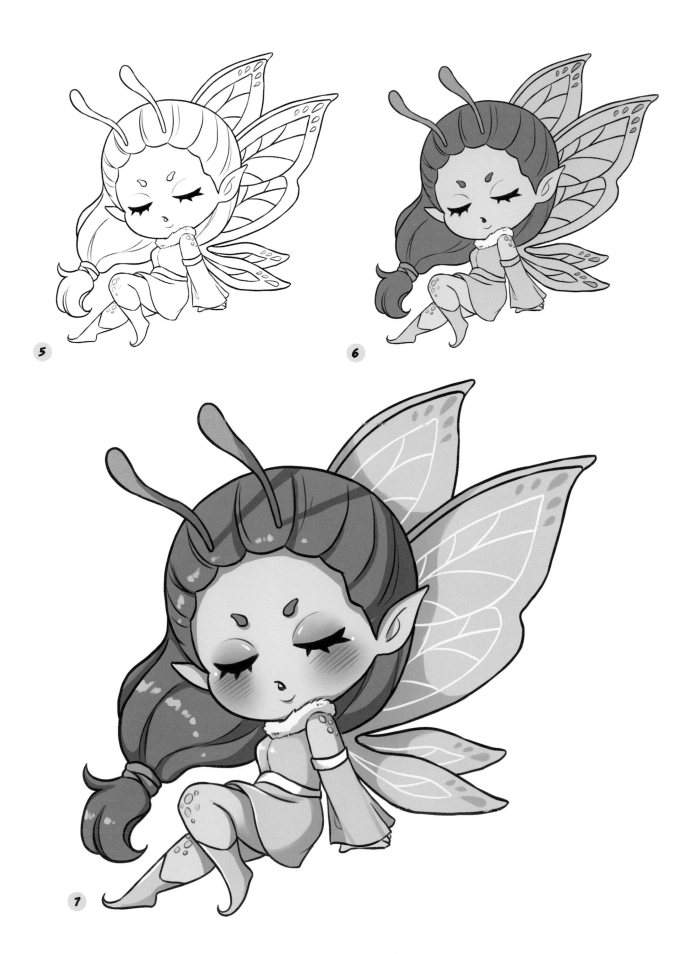

INNOCENT VAMPIRE

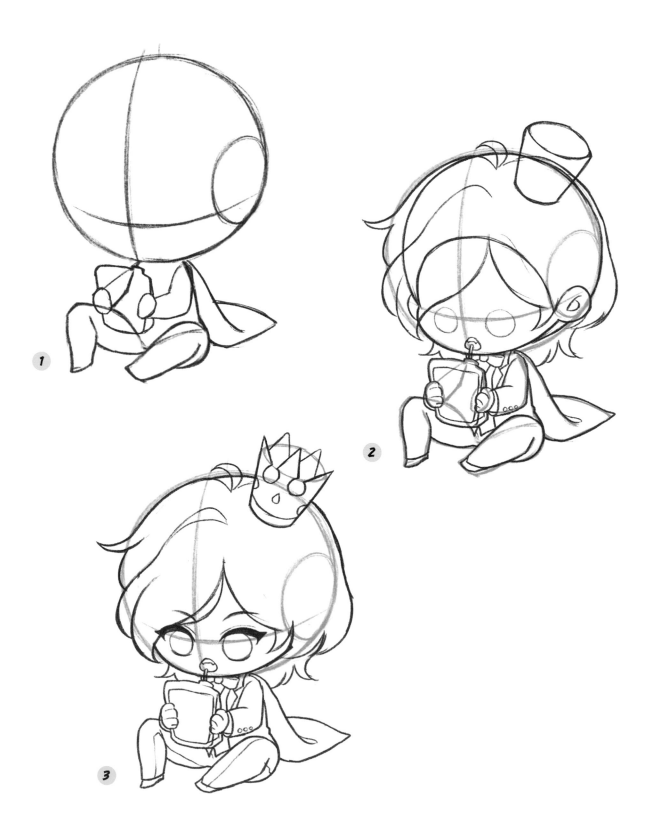

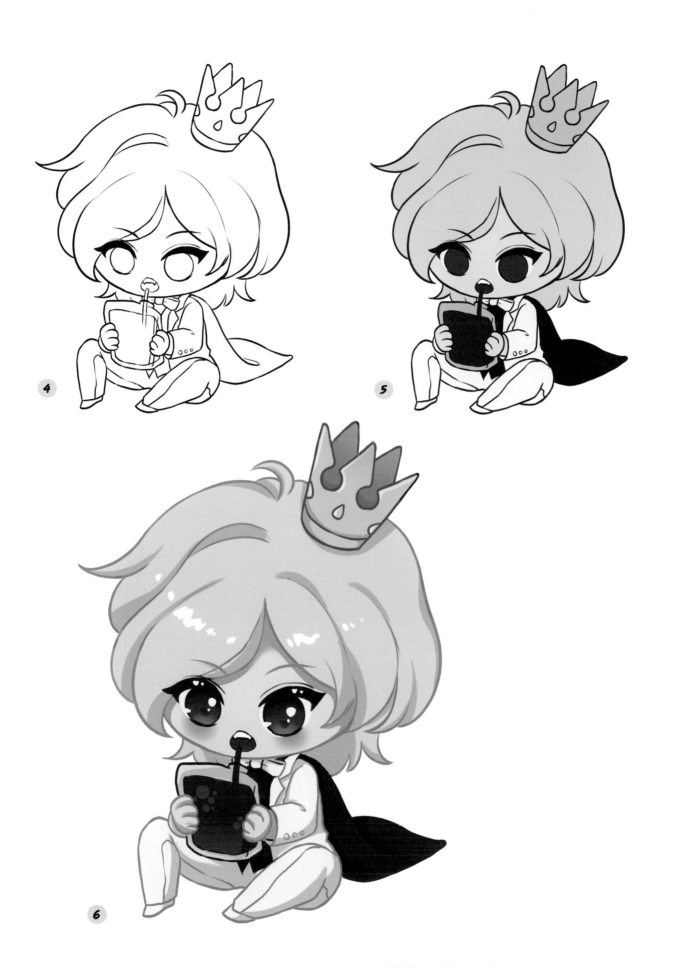

SILLY-CUTE ZOMBIE

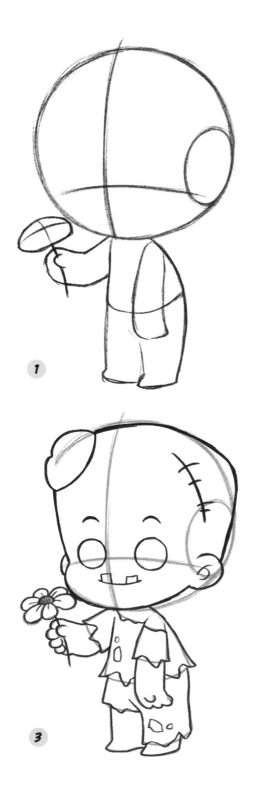

1

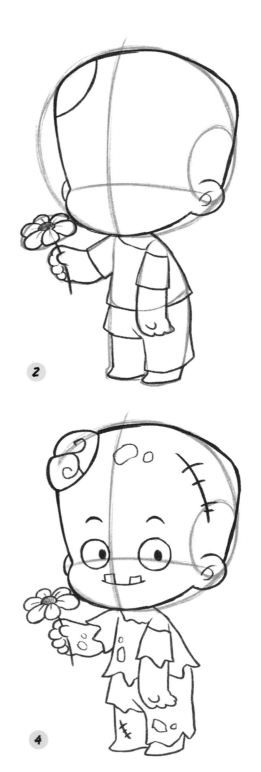

2

3

4

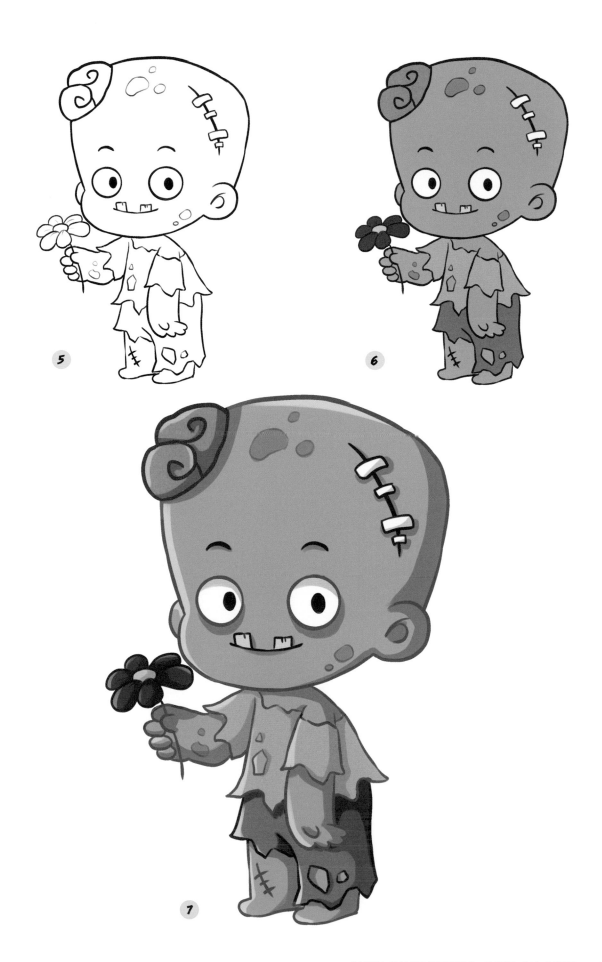

WEREWOLF GIRL

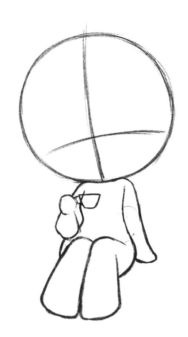

1

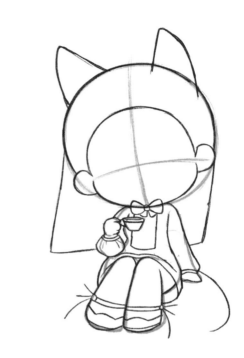

2

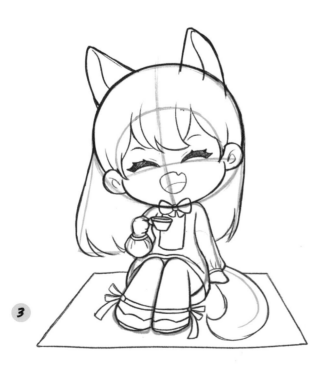

3

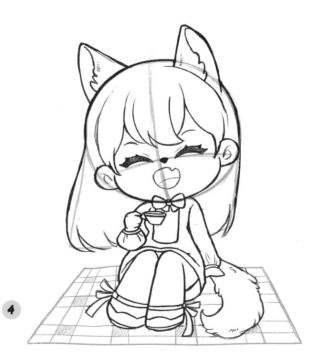

4

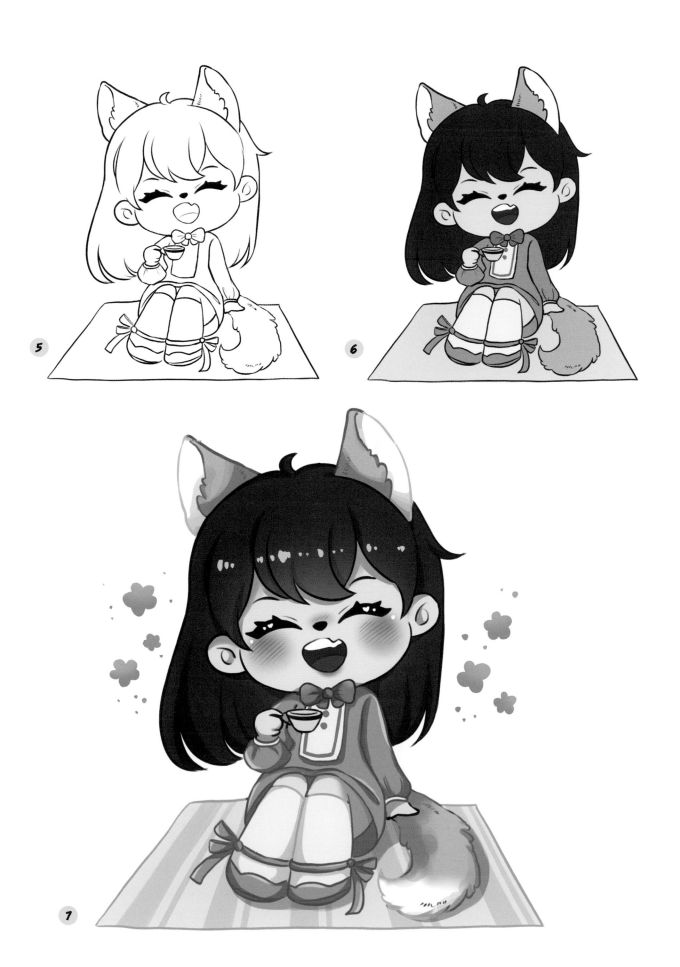

FOX GIRL

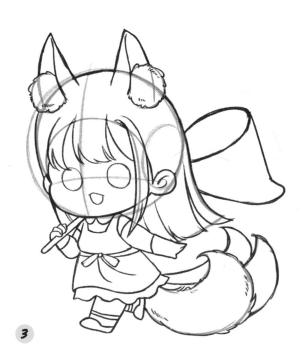

1

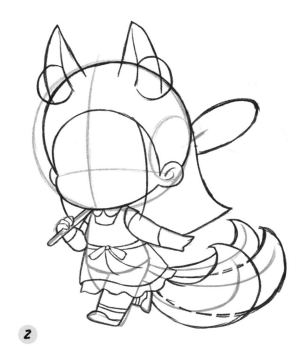

2

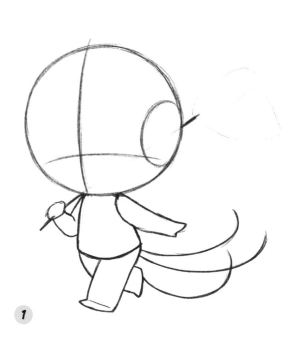

3

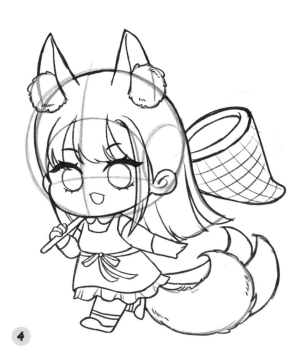

4

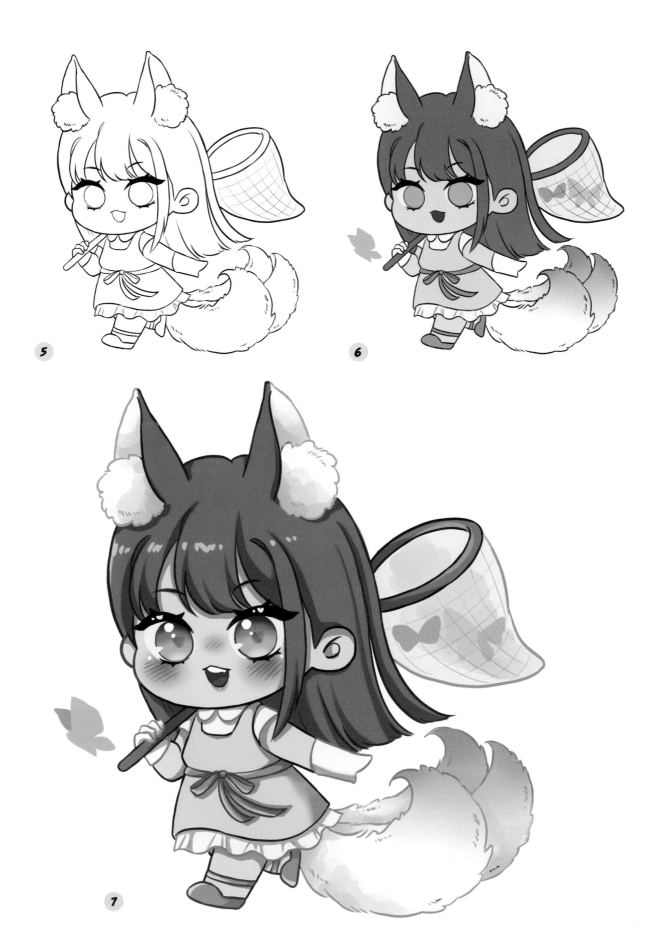

5

6

7

BEAR BOY

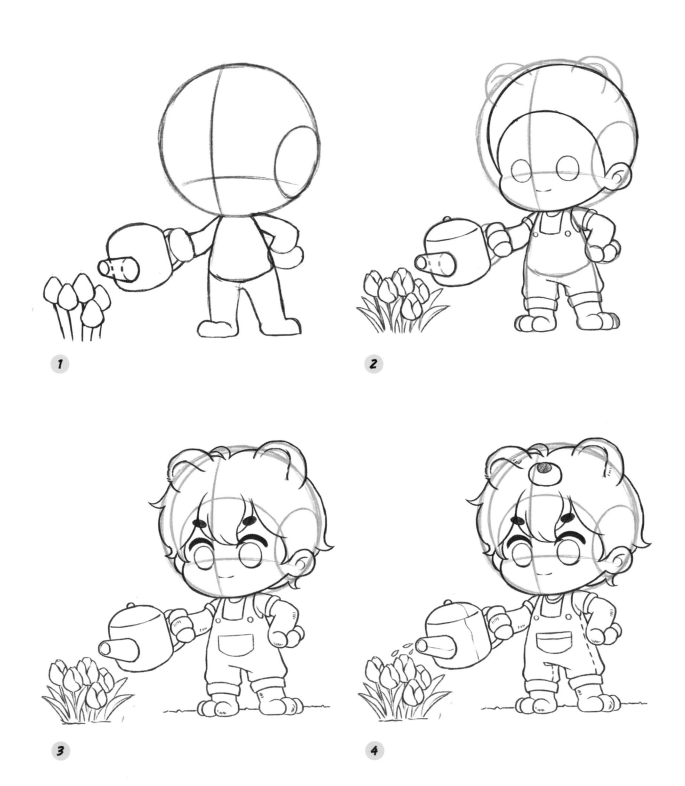

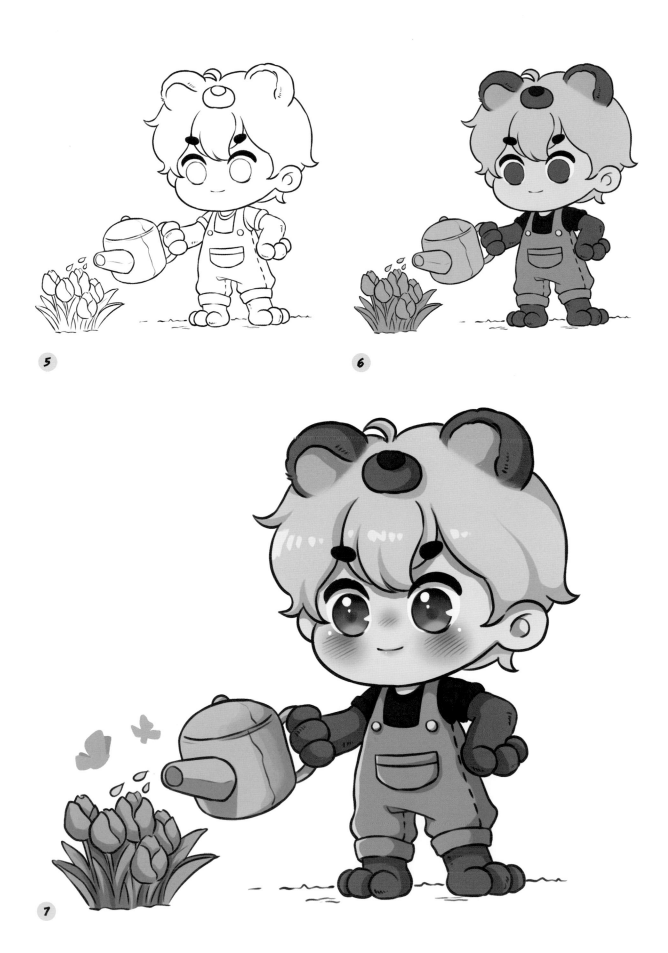

5

6

7

BUNNY BAKER

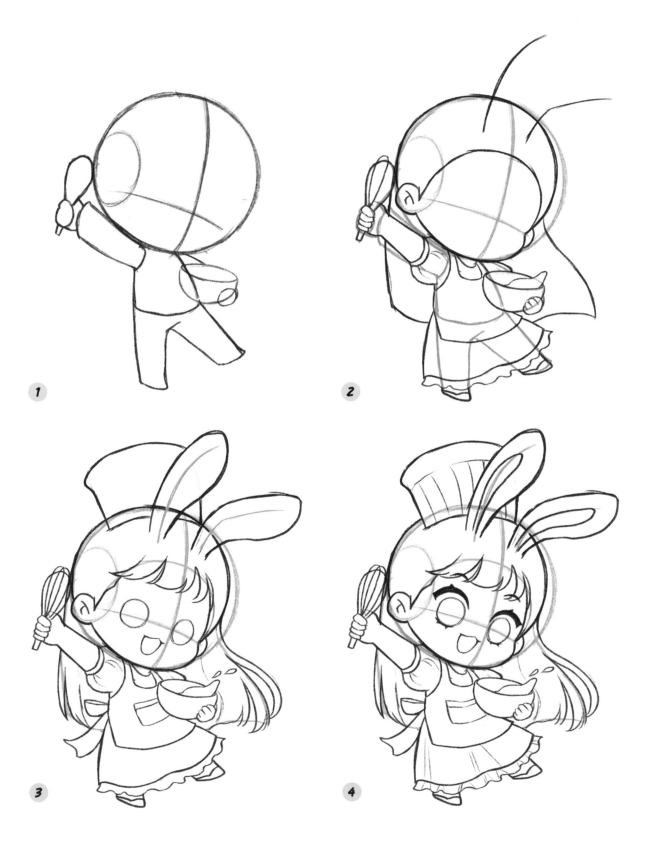

1

2

3

4

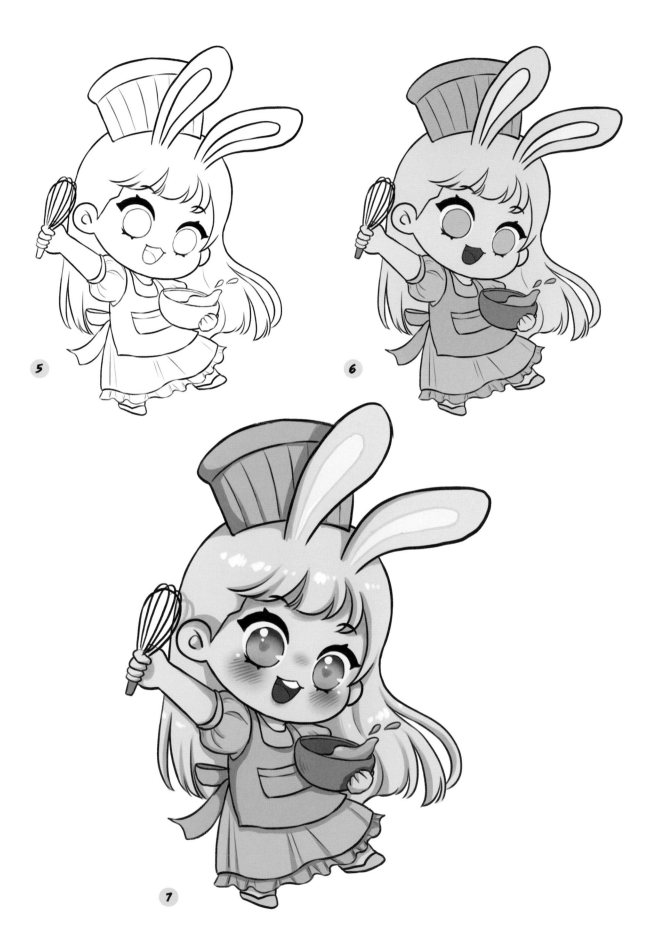

NEW GENERATION SUPERHERO

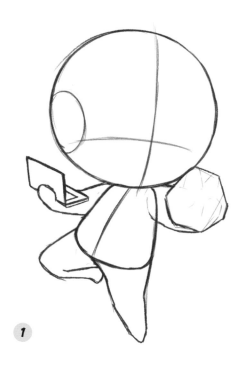

1

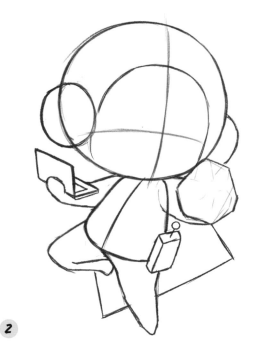

2

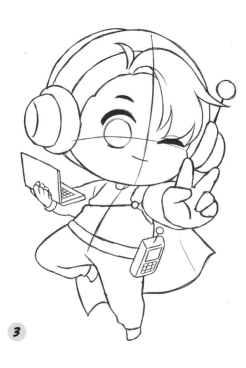

3

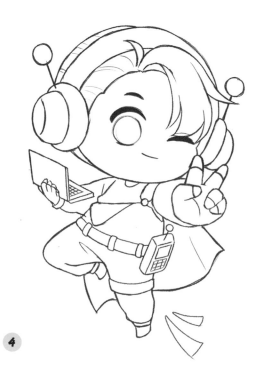

4

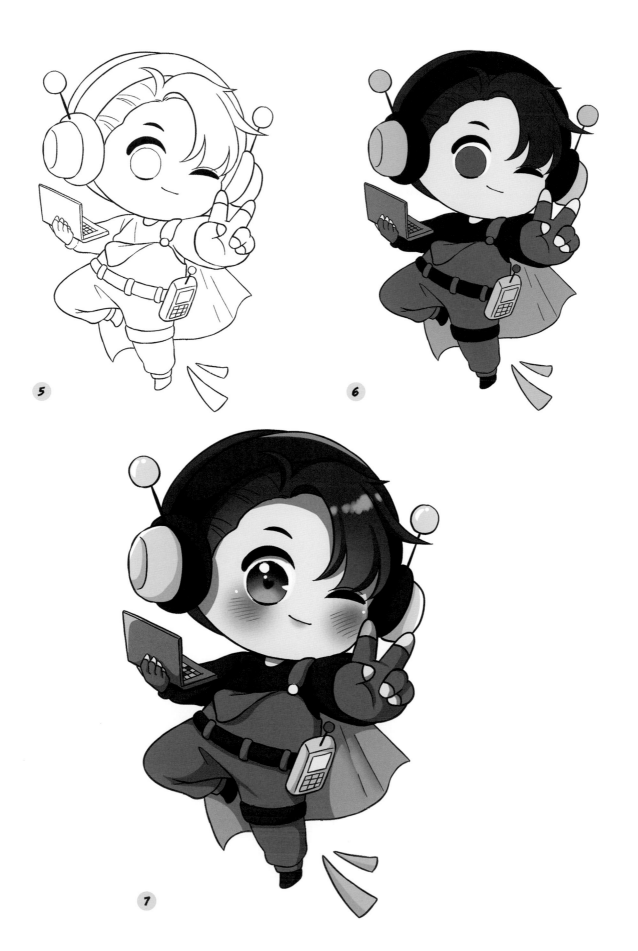

SHOPPING ALIEN

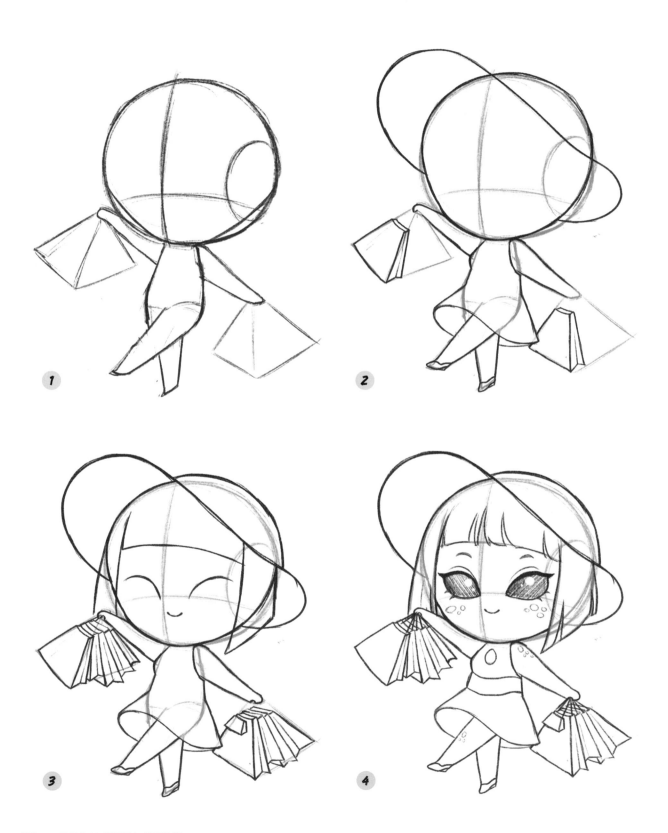

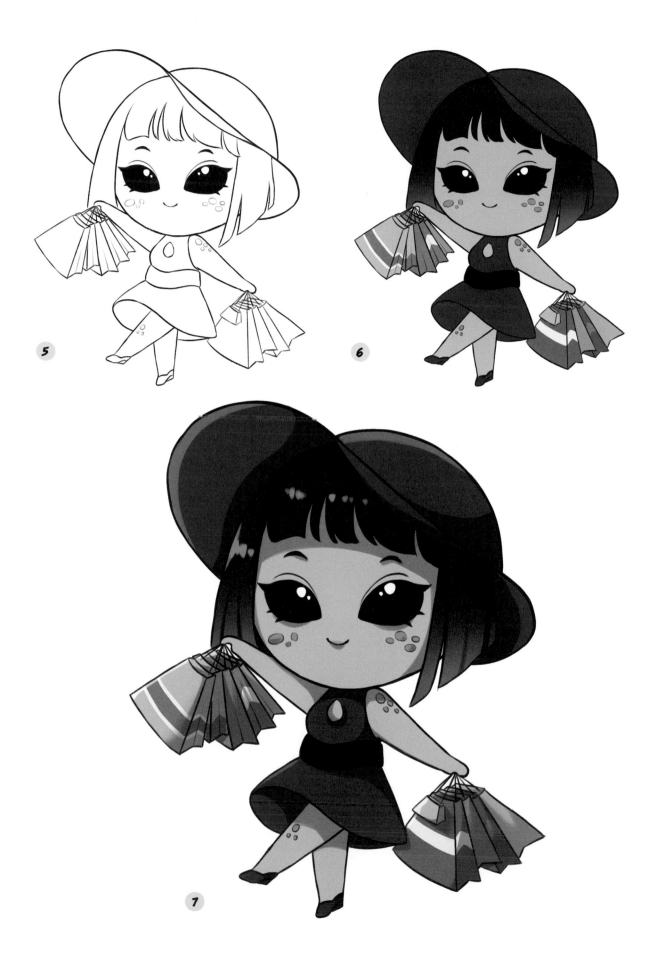

5

6

7

PIRATE

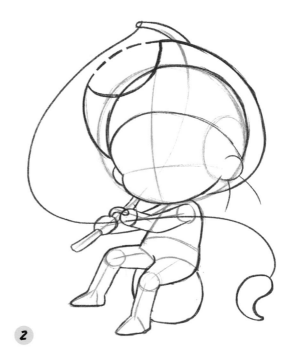

1

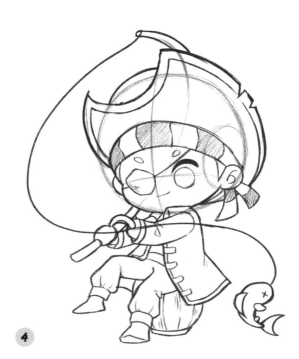

2

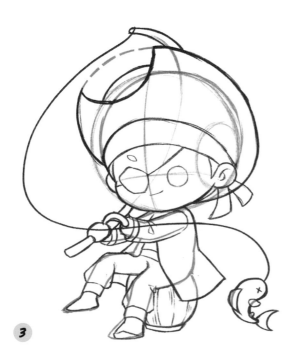

3

4

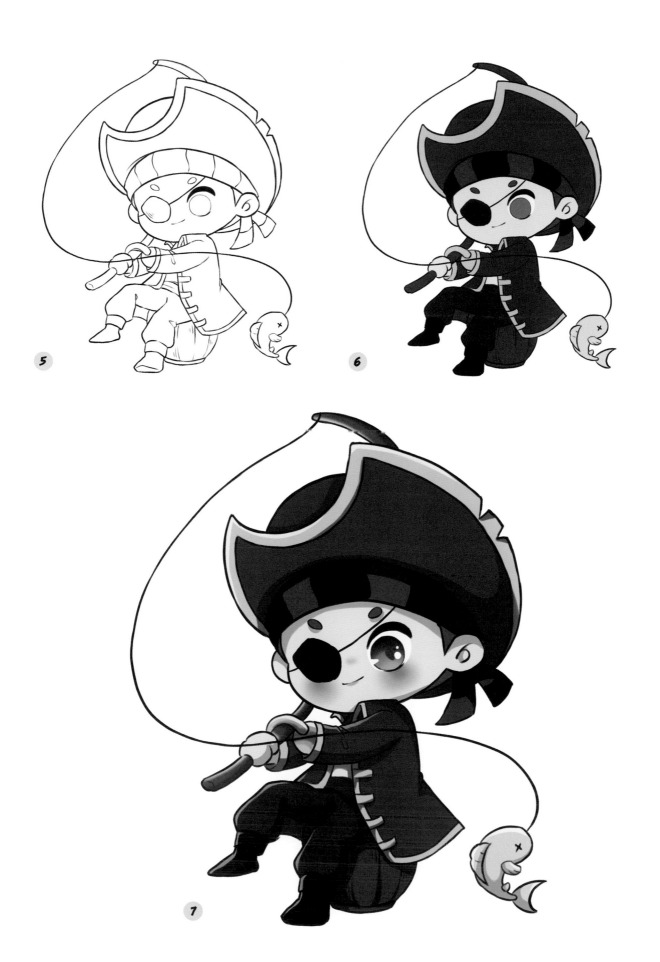

BABY SHARK

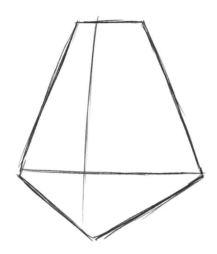

1

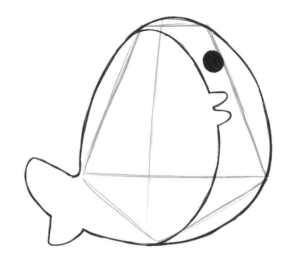

2

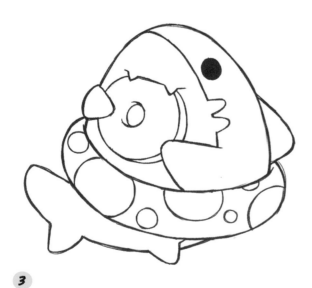

3

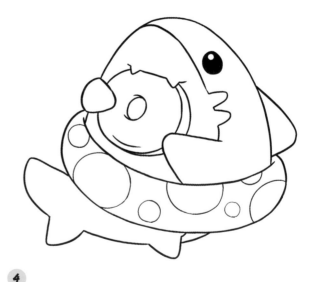

4

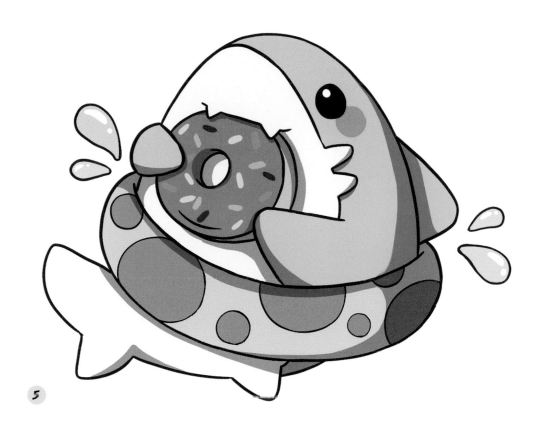

5

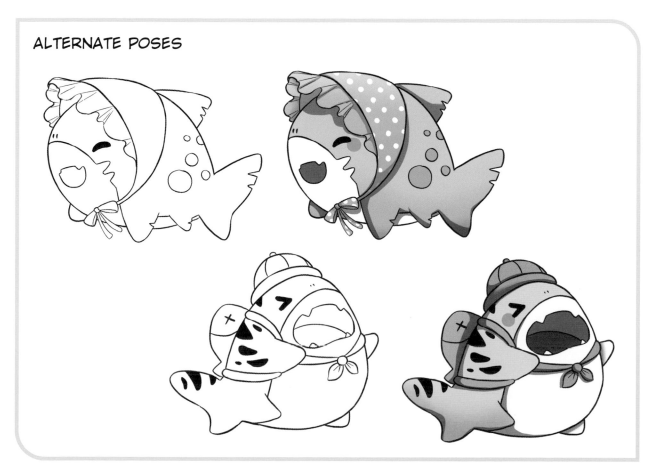

ALTERNATE POSES

ANGRY MUMMY

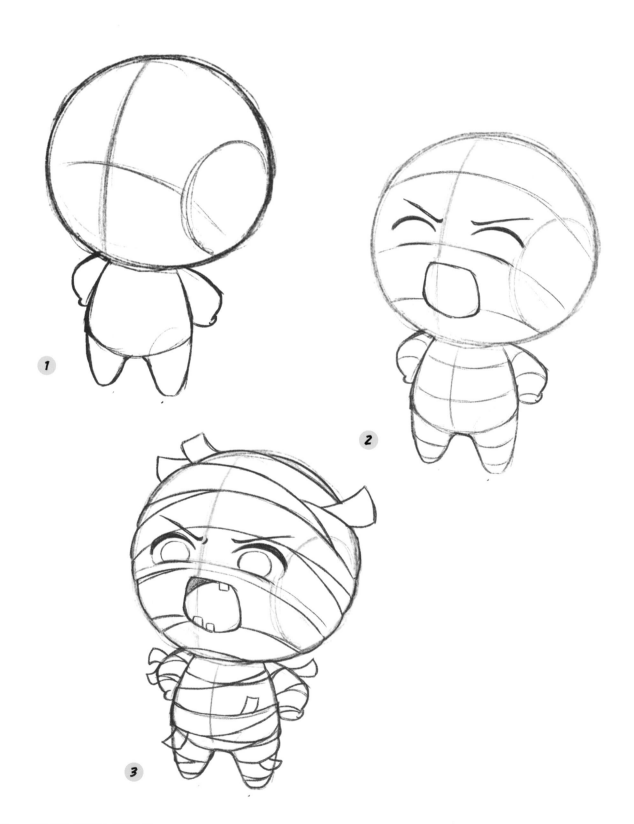

1

2

3

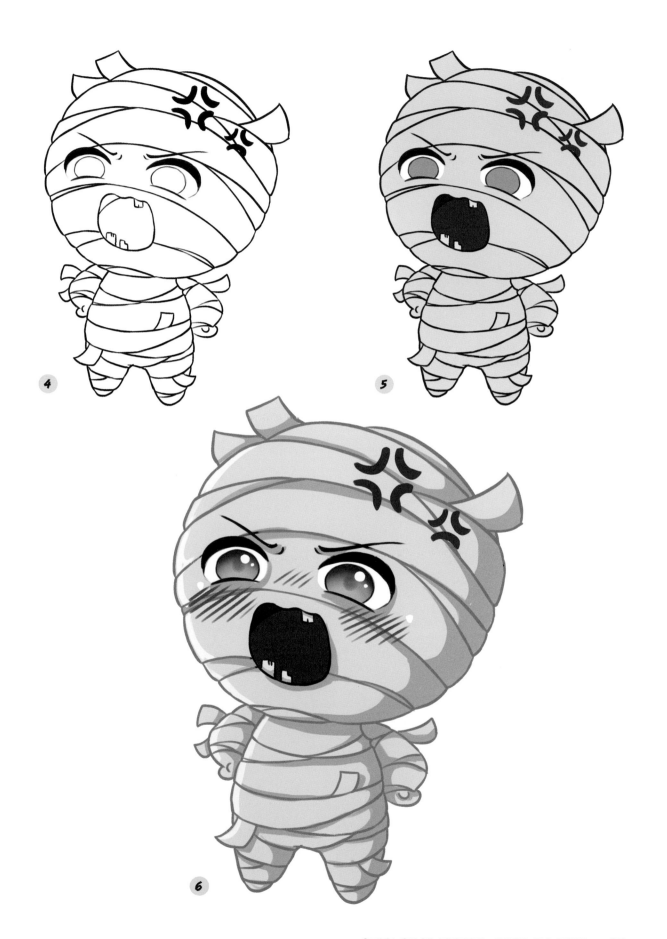

BRAVE ADVENTURER

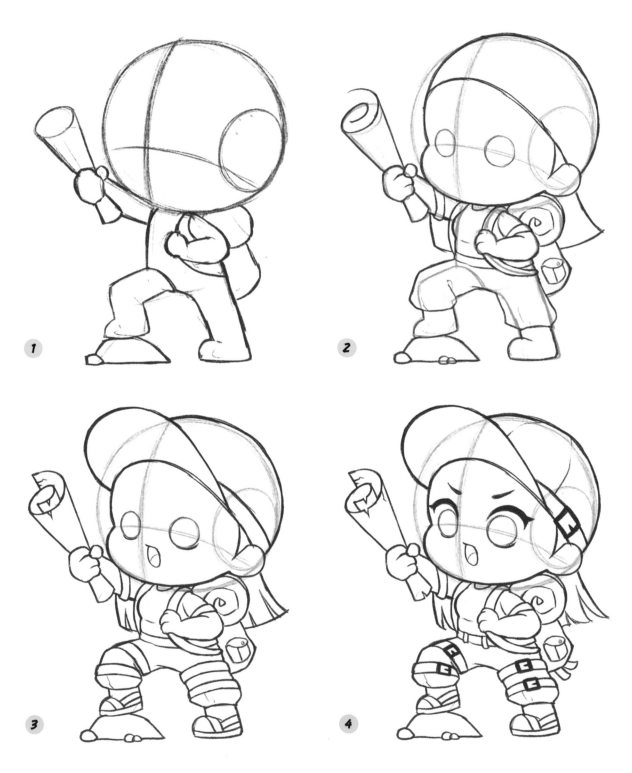

1

2

3

4

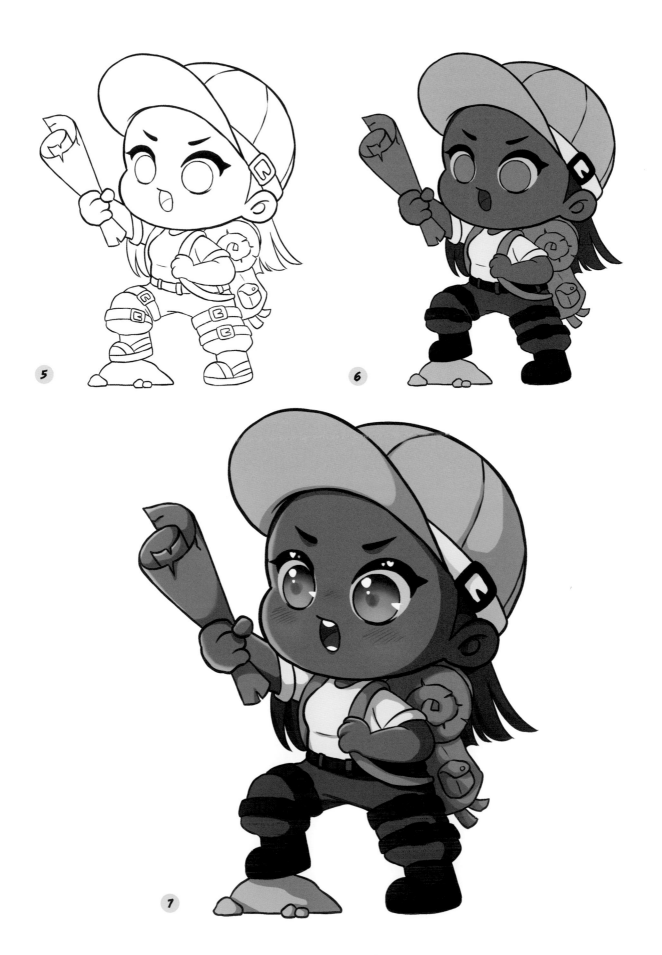

PLUSHIE DOCTOR

1

2

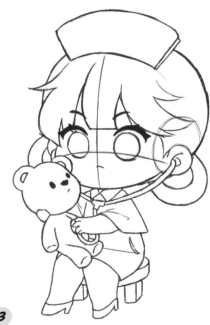

3

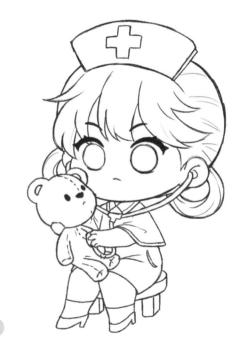

4

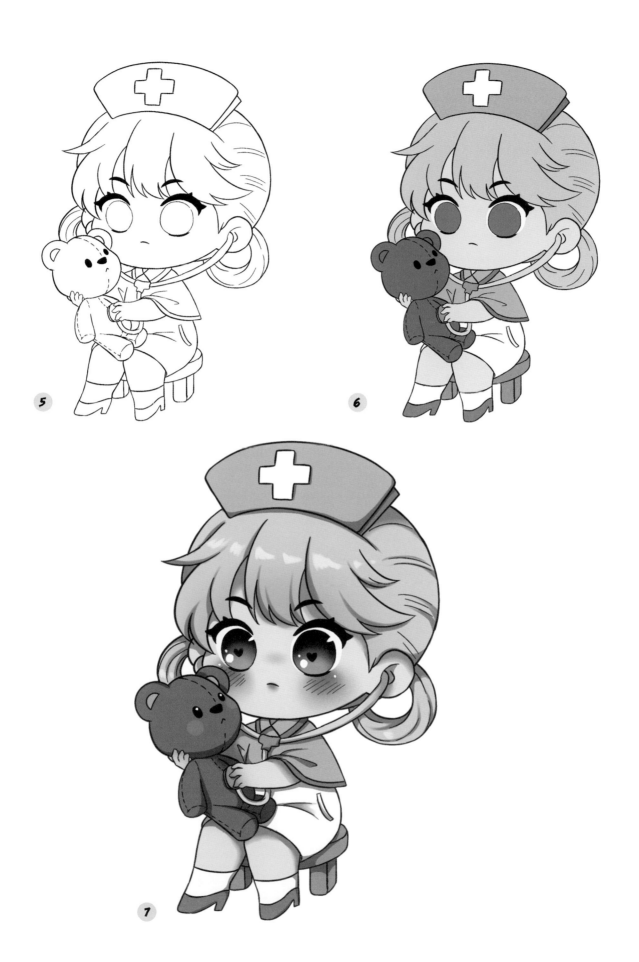

CHEERLEADER

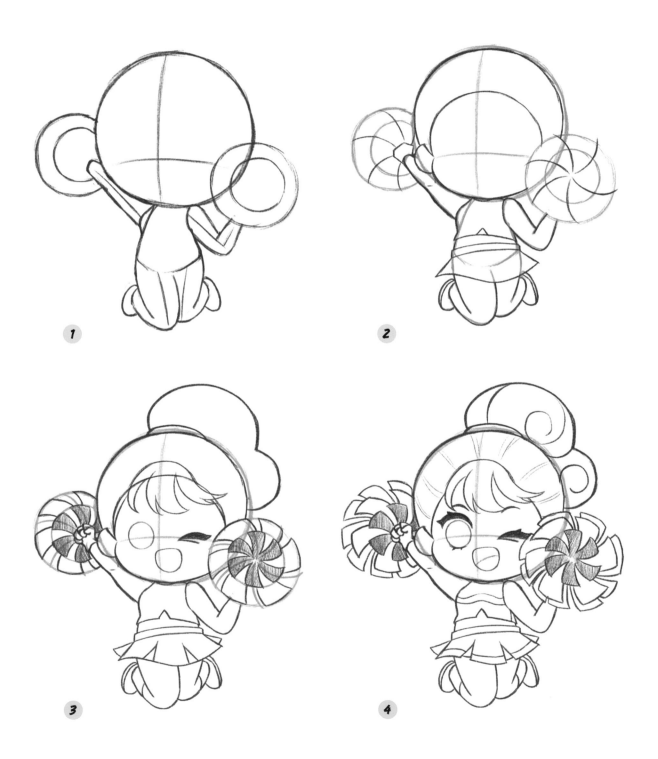

1

2

3

4

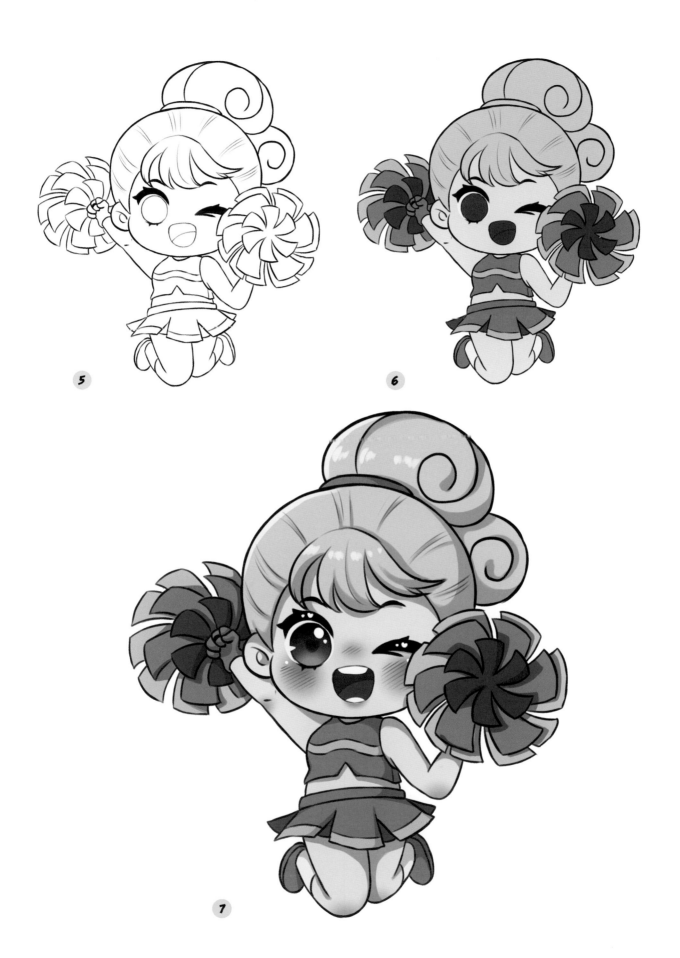

5

6

7

BASEBALL PLAYER

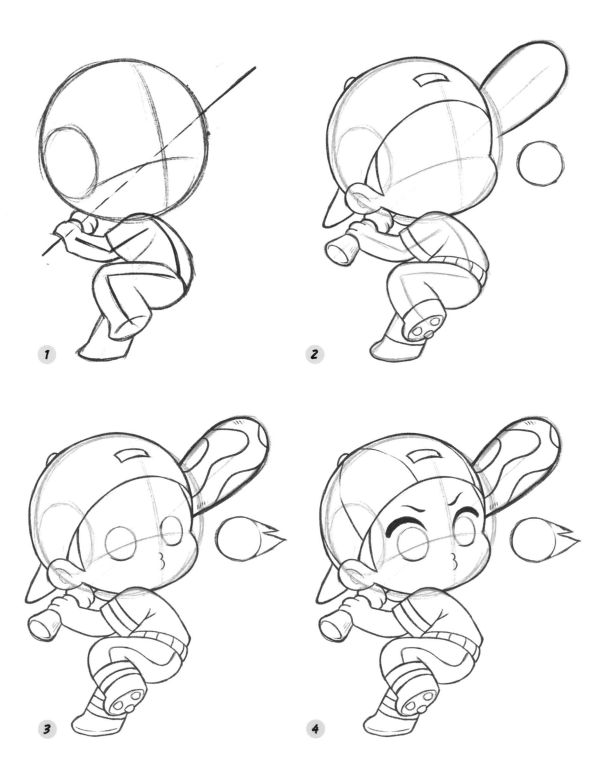

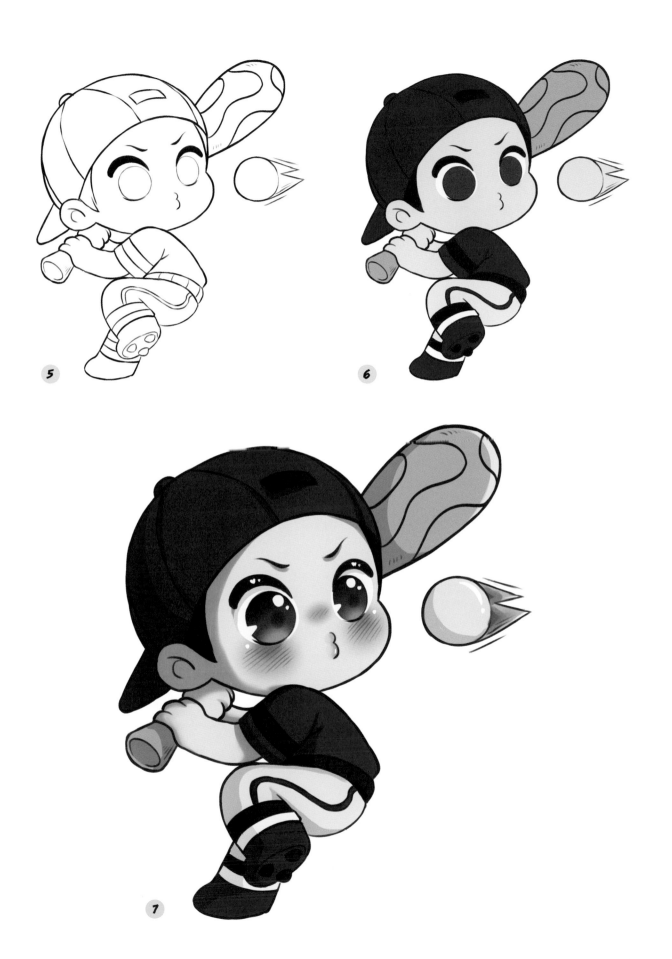

BASKETBALL PLAYER

1

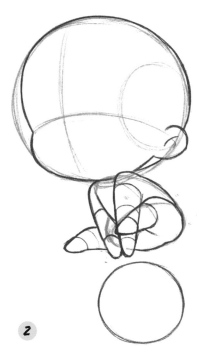

2

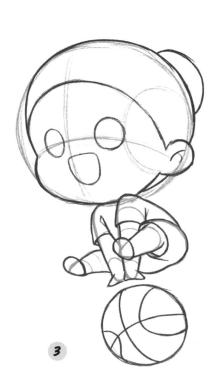

3

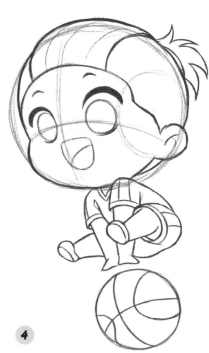

4

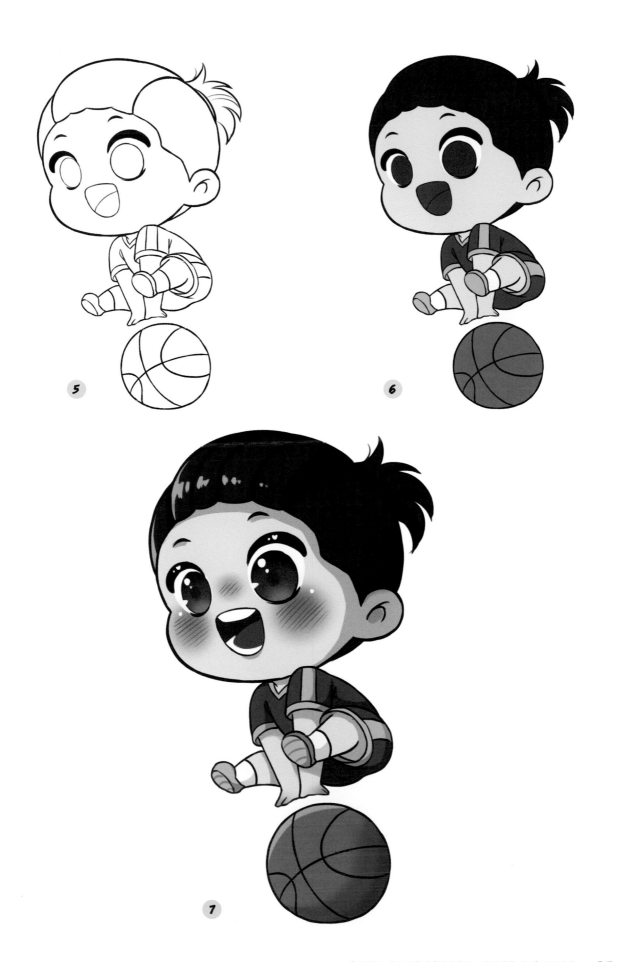

SWIMMER

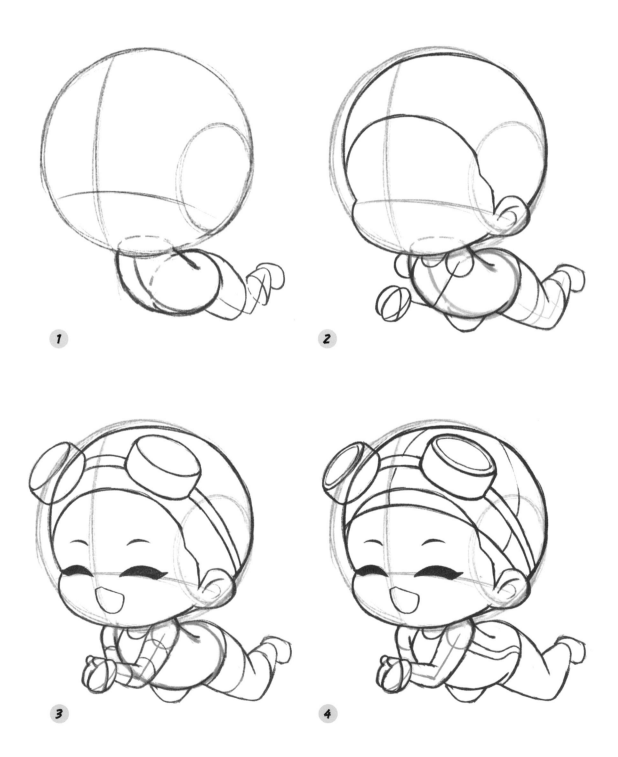

1

2

3

4

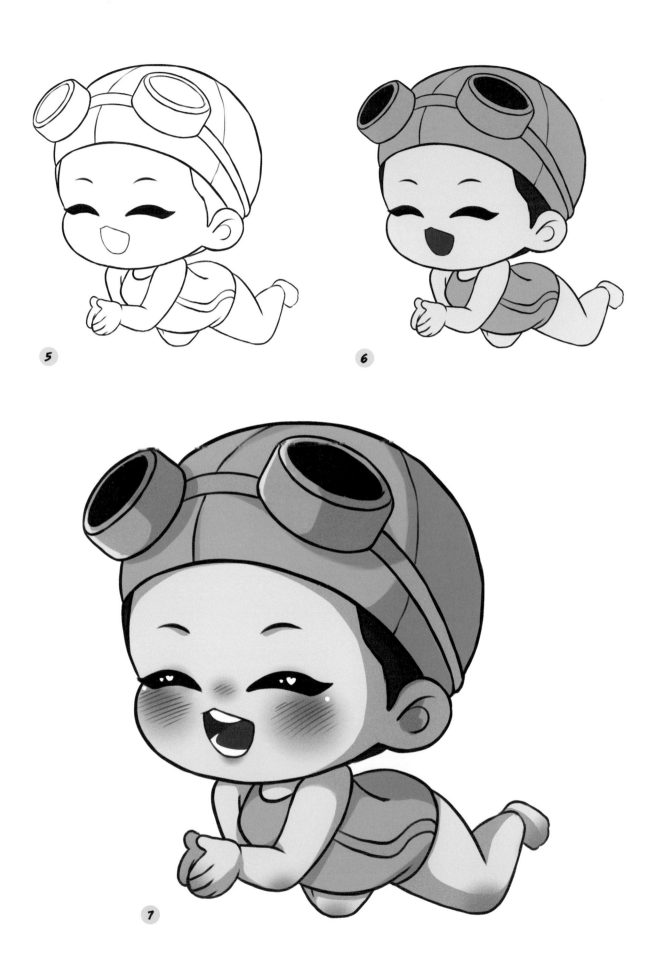

5

6

7

YOUTH IDOL

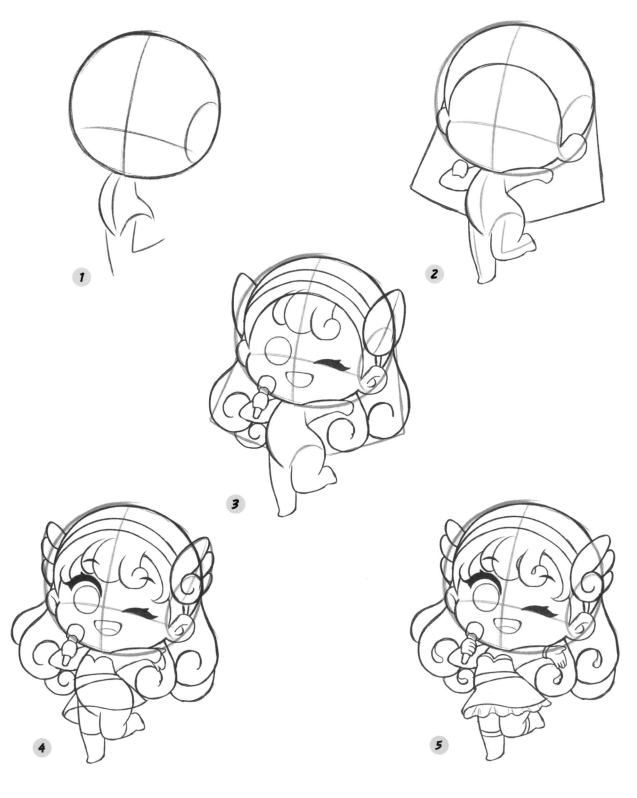

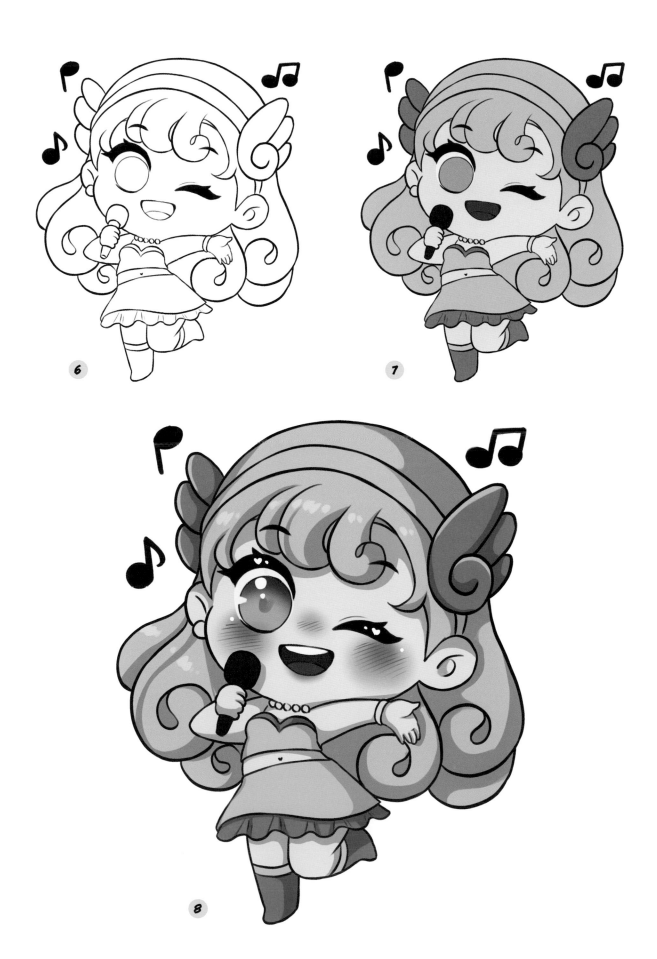

SWEET SCHOOLGIRL

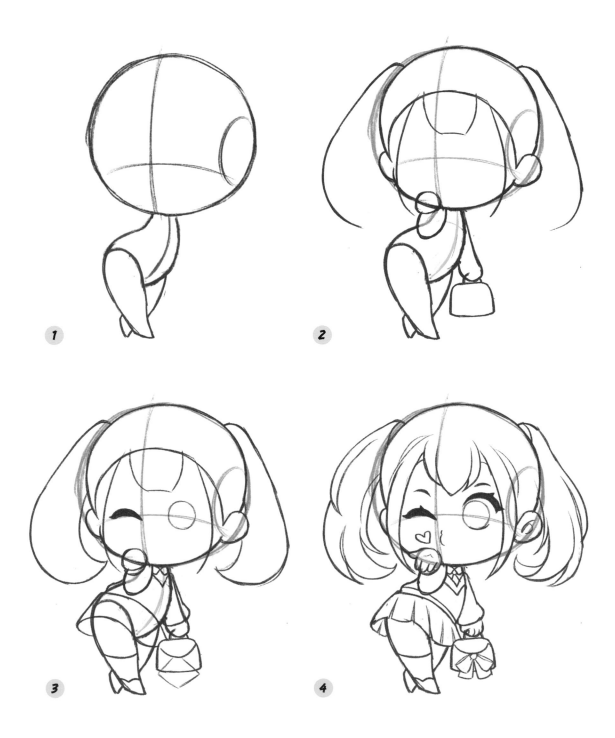

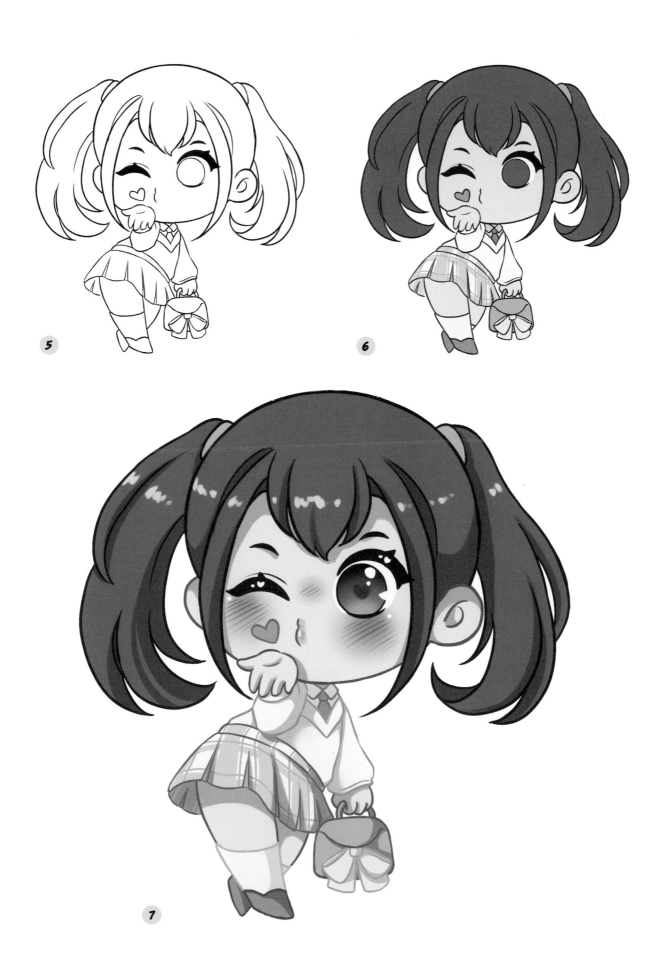

5

6

7

ACTION MOVIE ACTOR

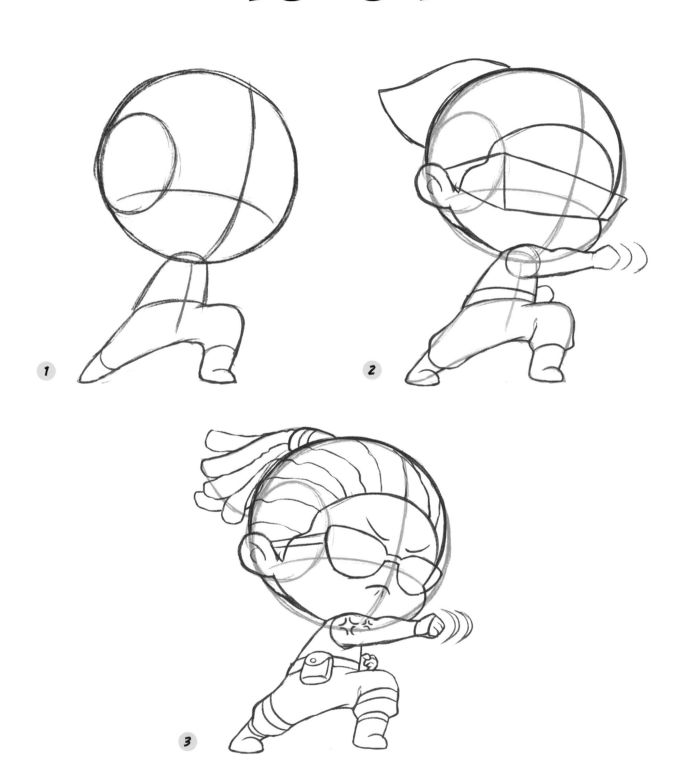

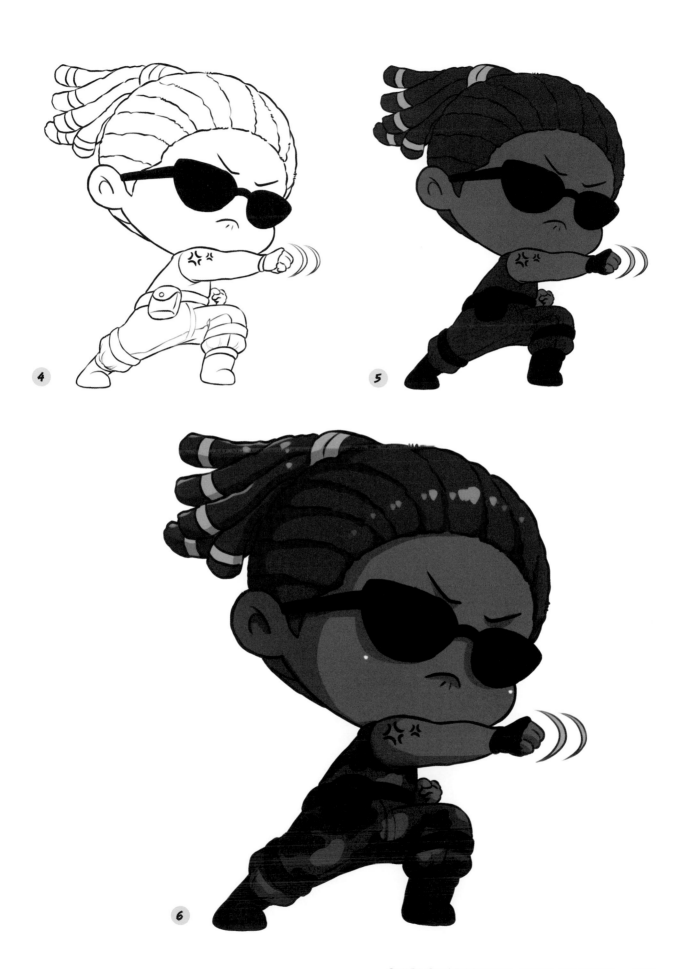

NINJA

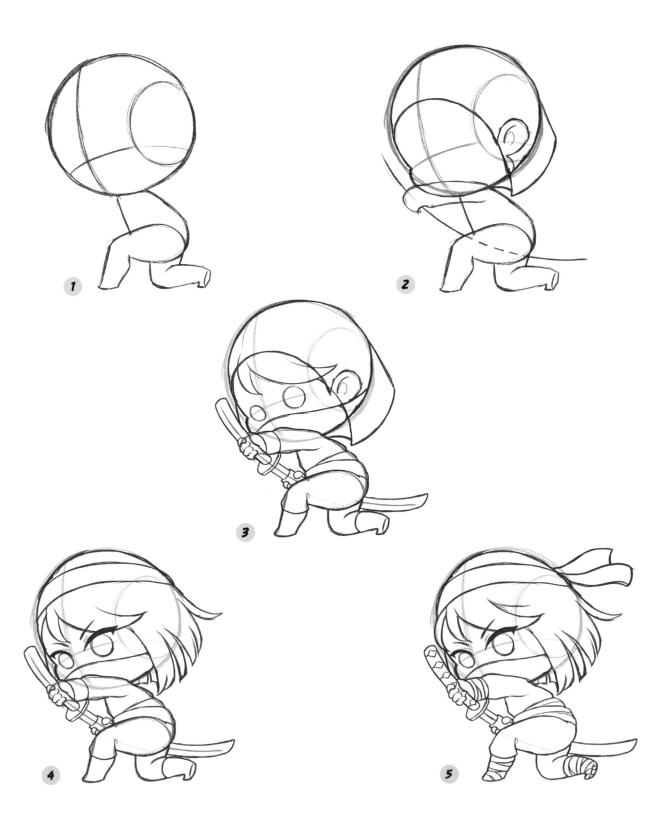

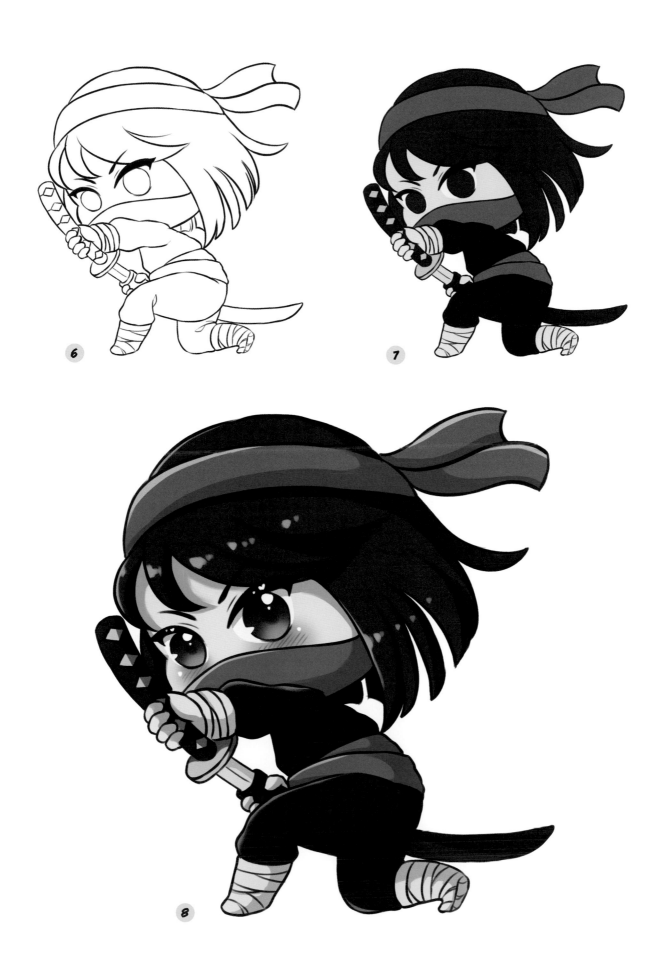

BALLERINA

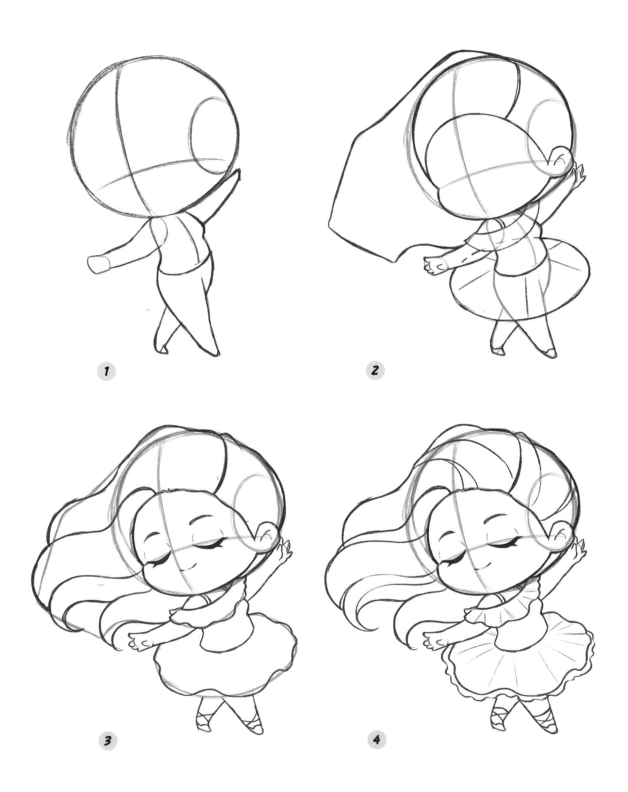

1

2

3

4

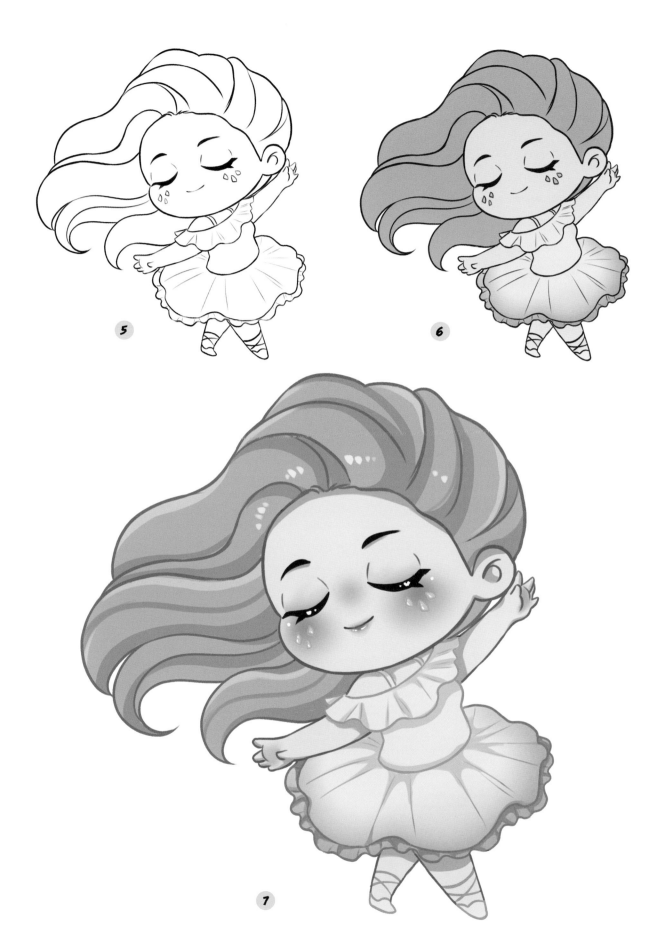

5

6

7

ARTIST

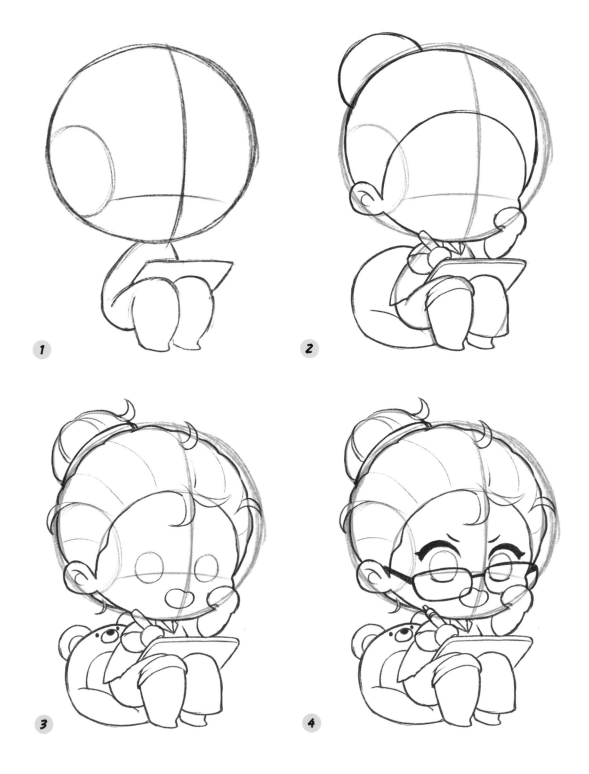

1

2

3

4

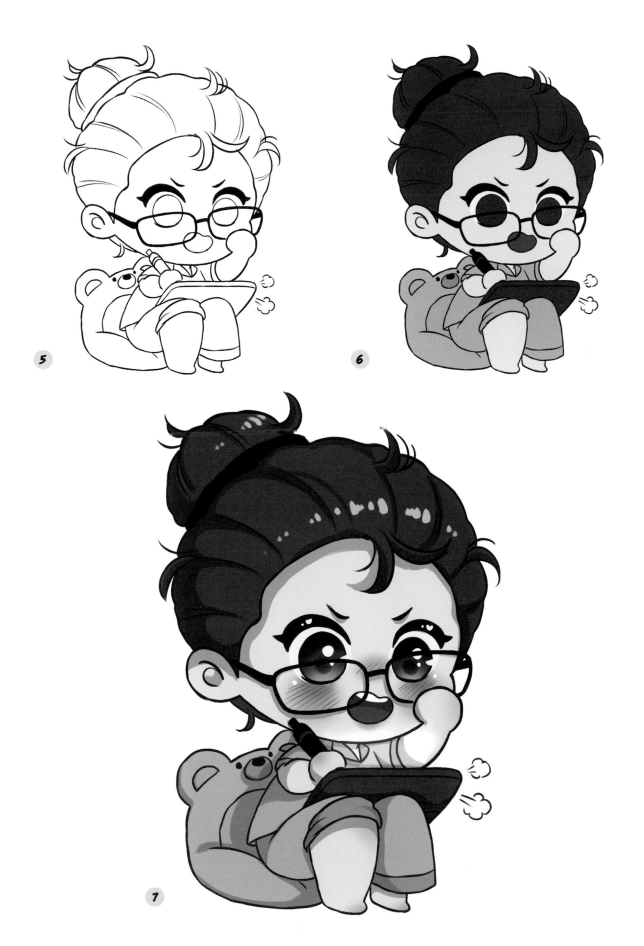

ASTRONAUT AND MOON

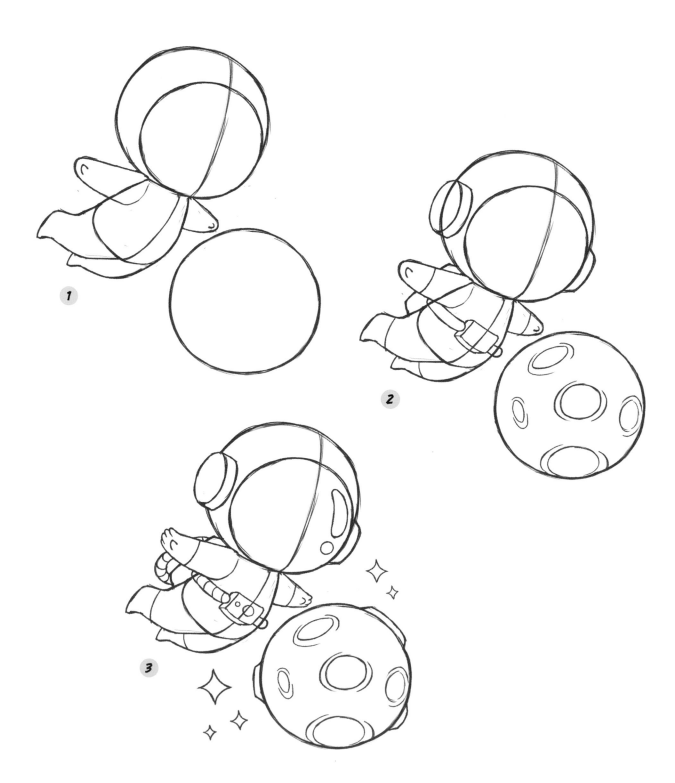

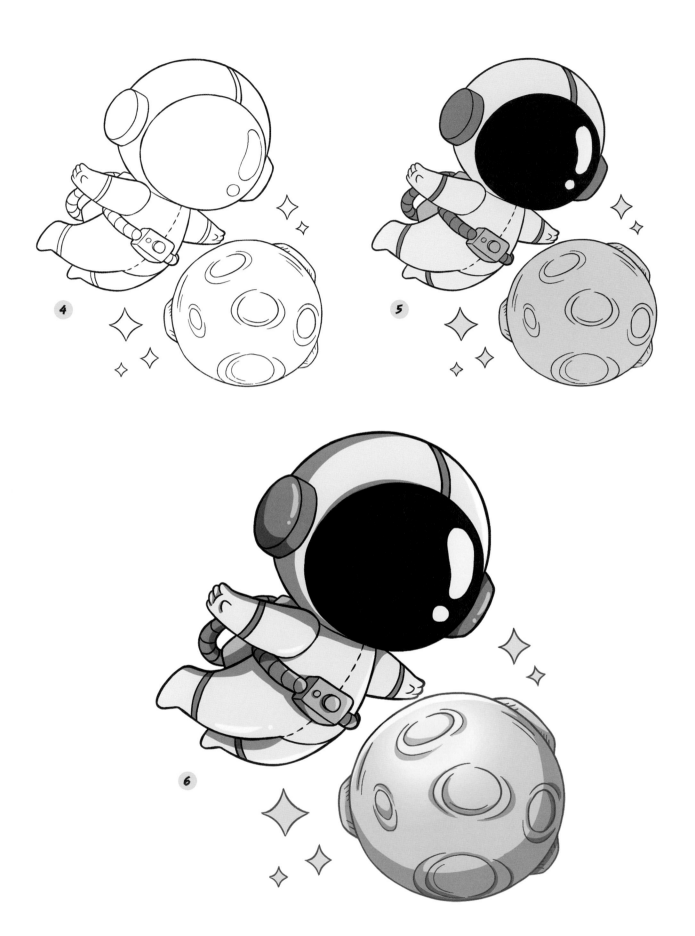

SHADOW KNIGHT

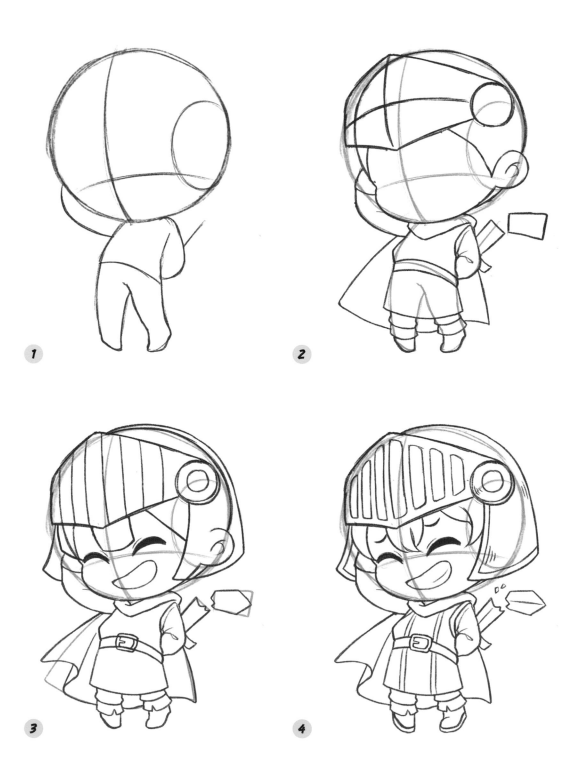

1

2

3

4

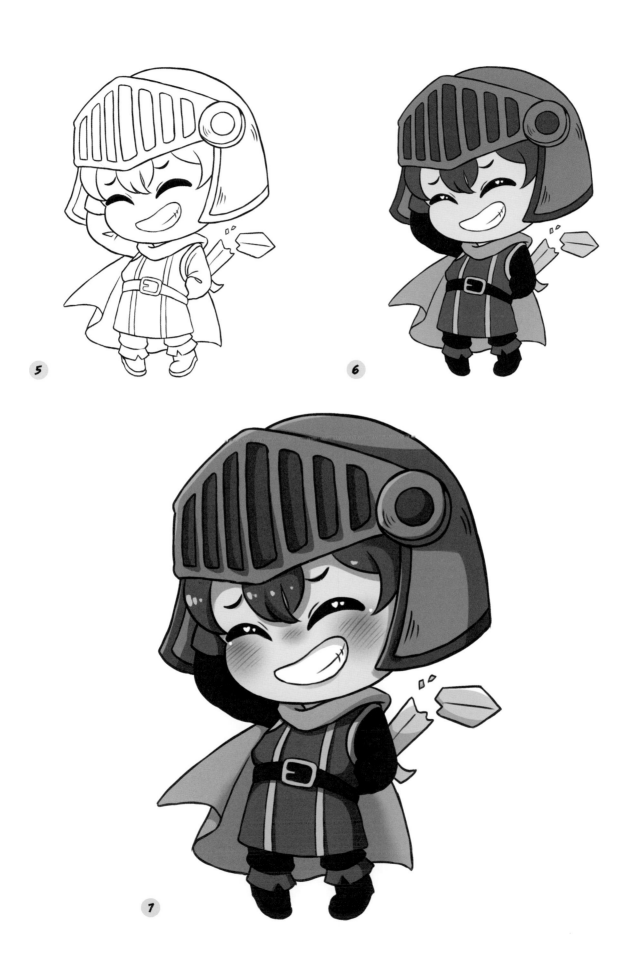

5

6

7

HIP-HOP COUPLE

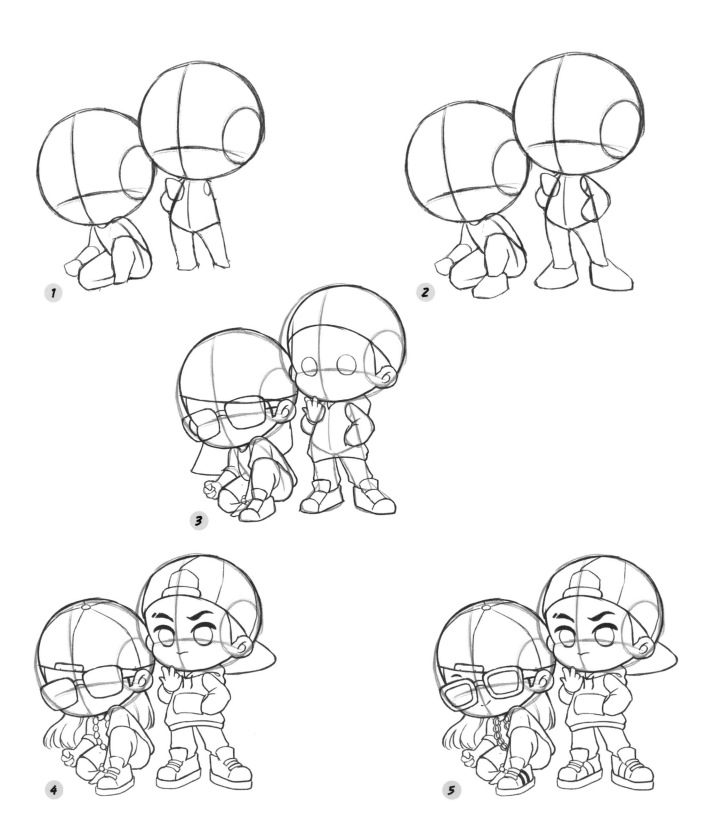

1

2

3

4

5

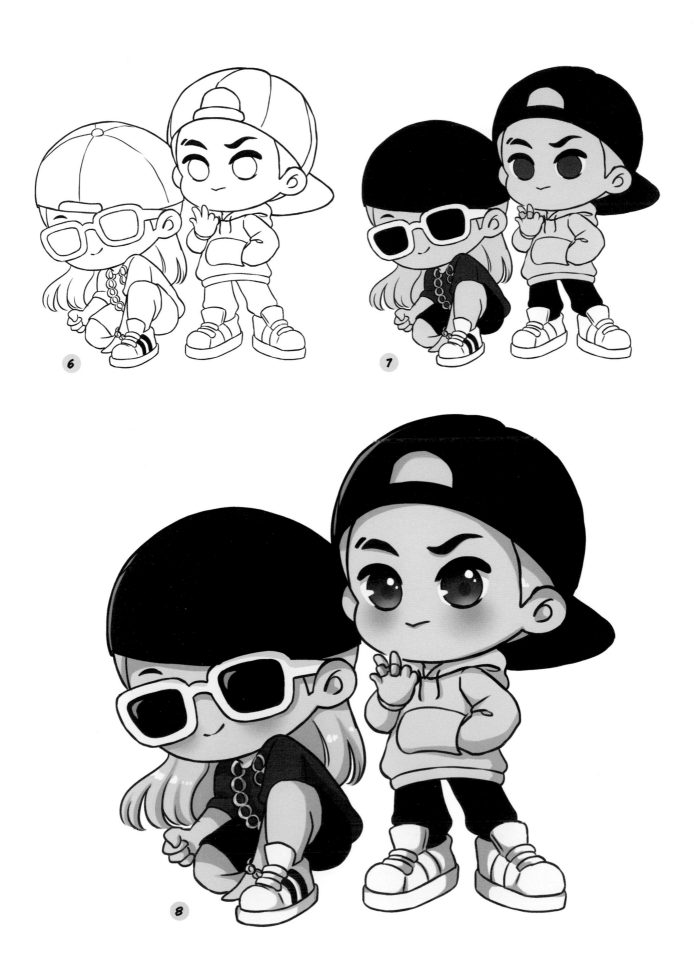

PRINCE AND PRINCESS

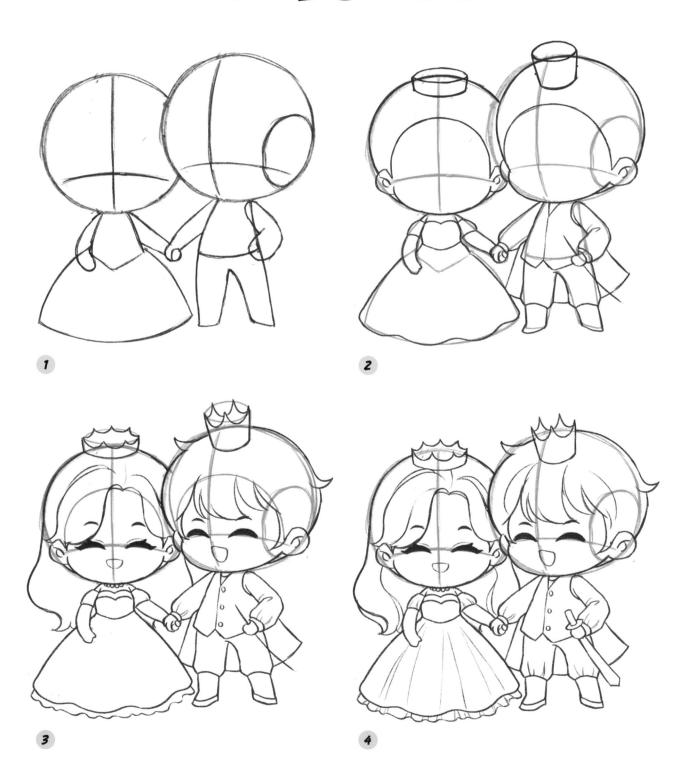

1

2

3

4

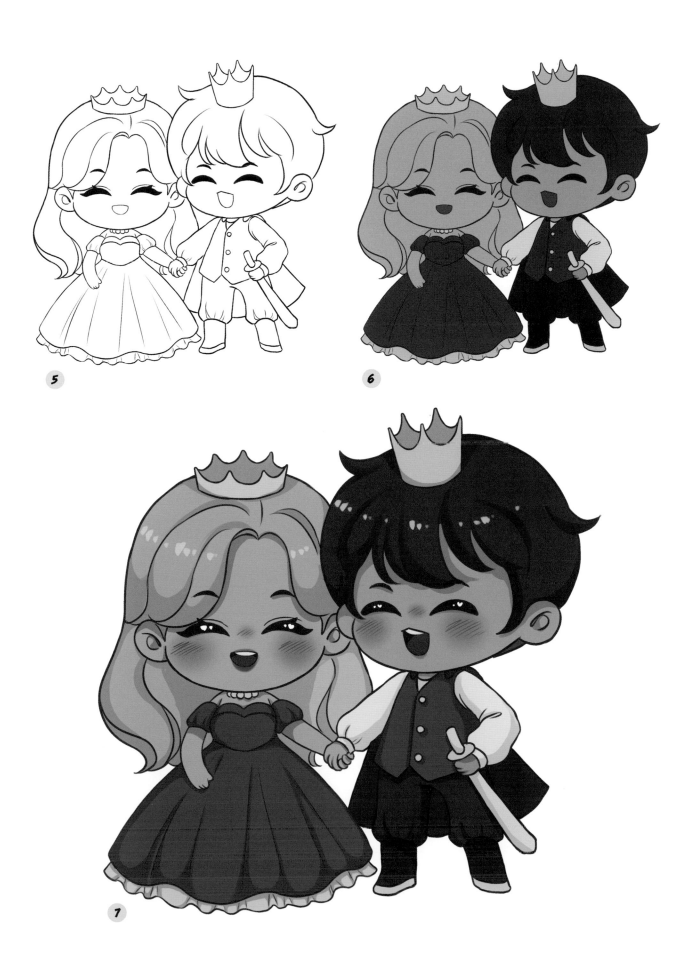

5

6

7

ELEMENTARY SCHOOL FRIENDS

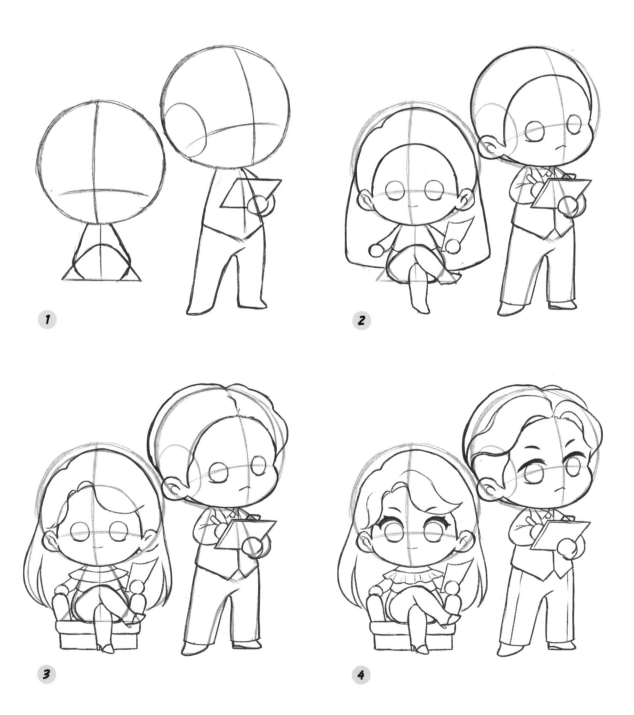

1

2

3

4

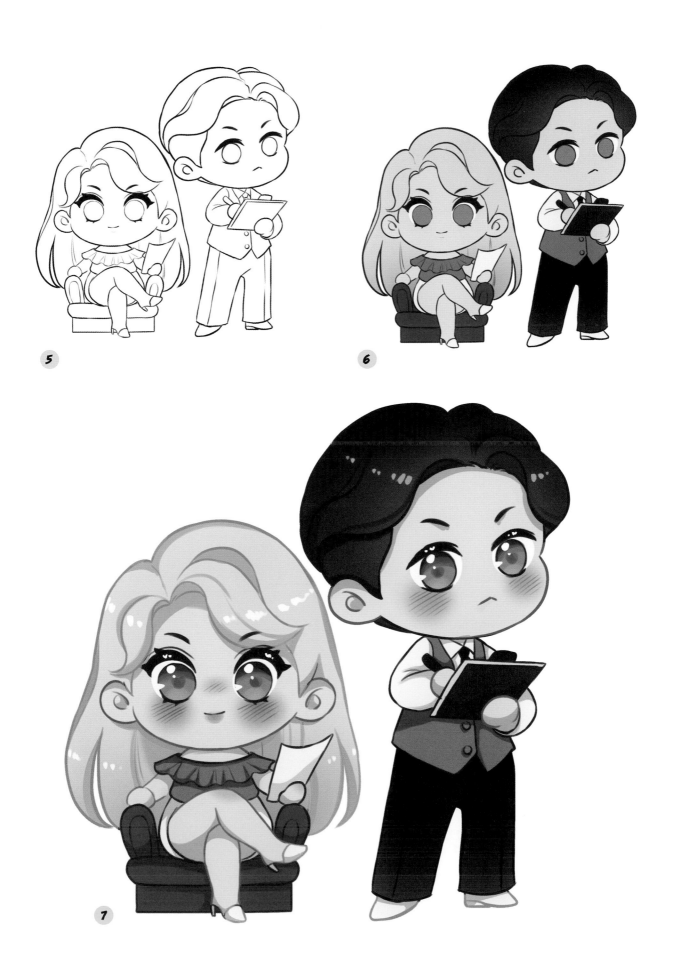

5

6

7

DRAGON

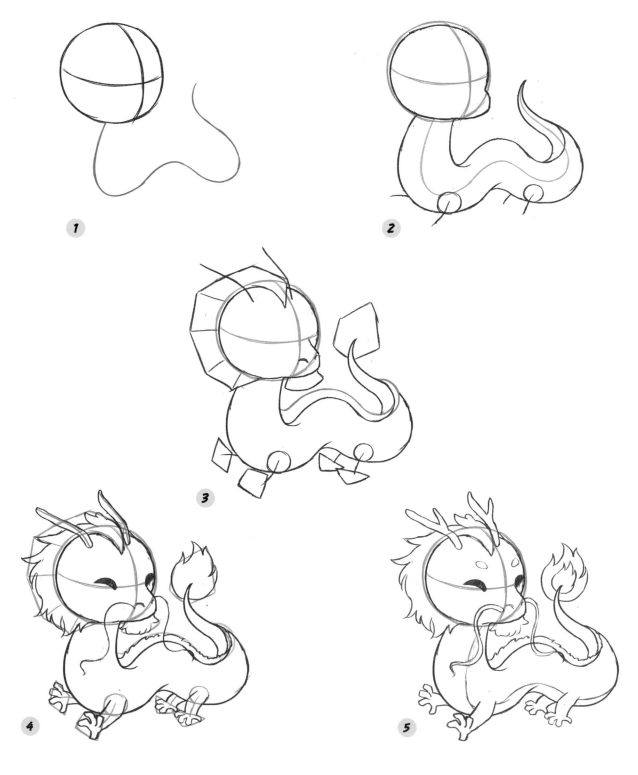

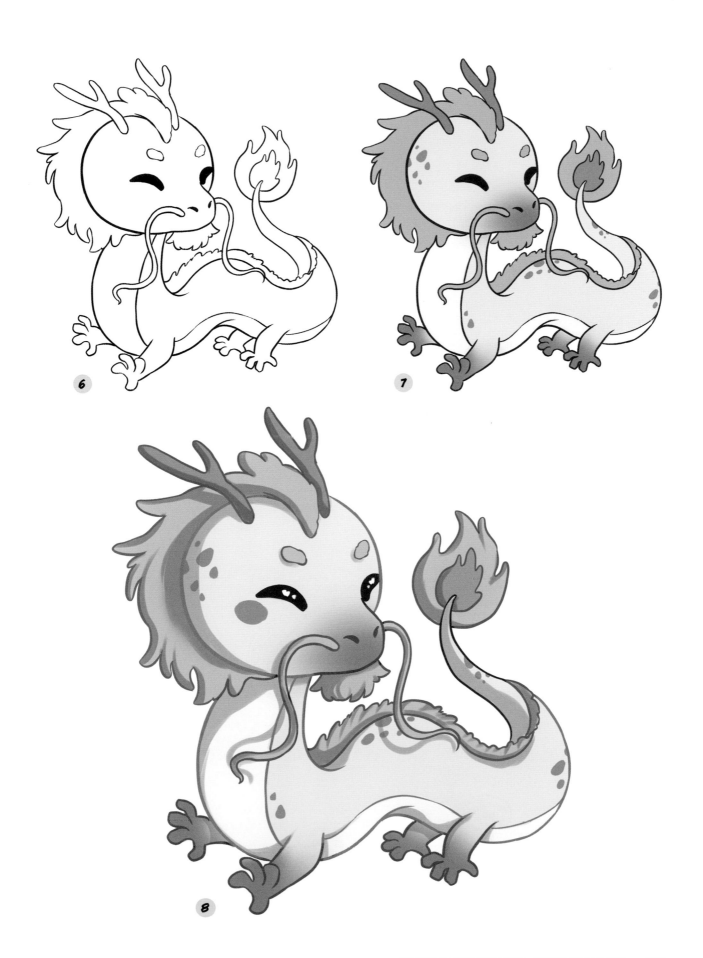

6

7

8

DINOSAUR

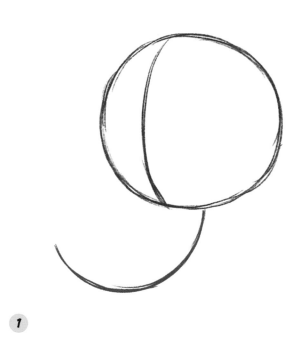

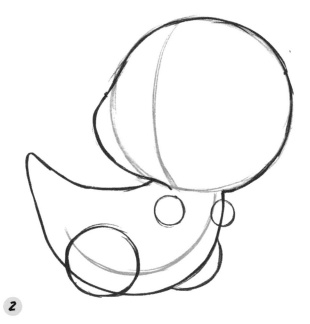

1

2

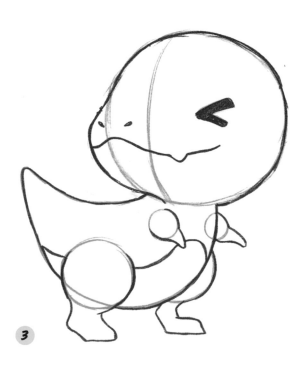

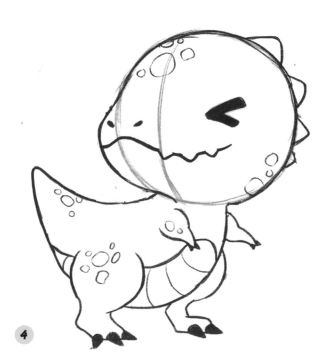

3

4

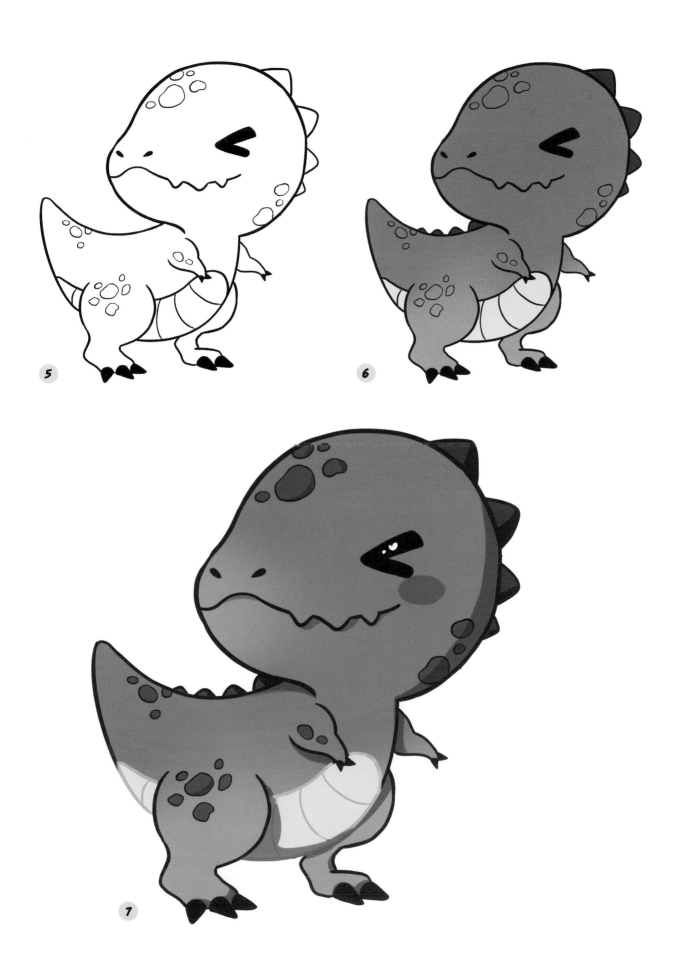

NINE-TAILS FOX

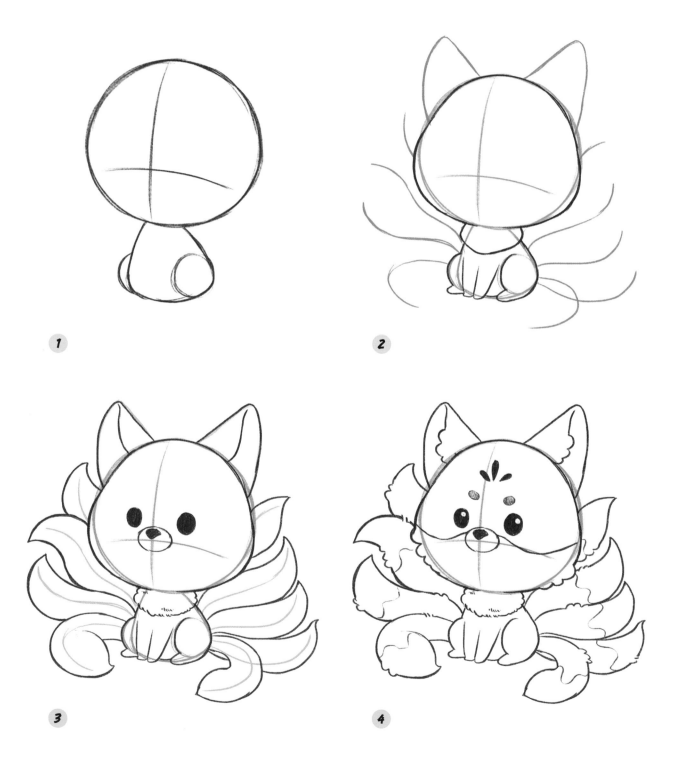

1

2

3

4

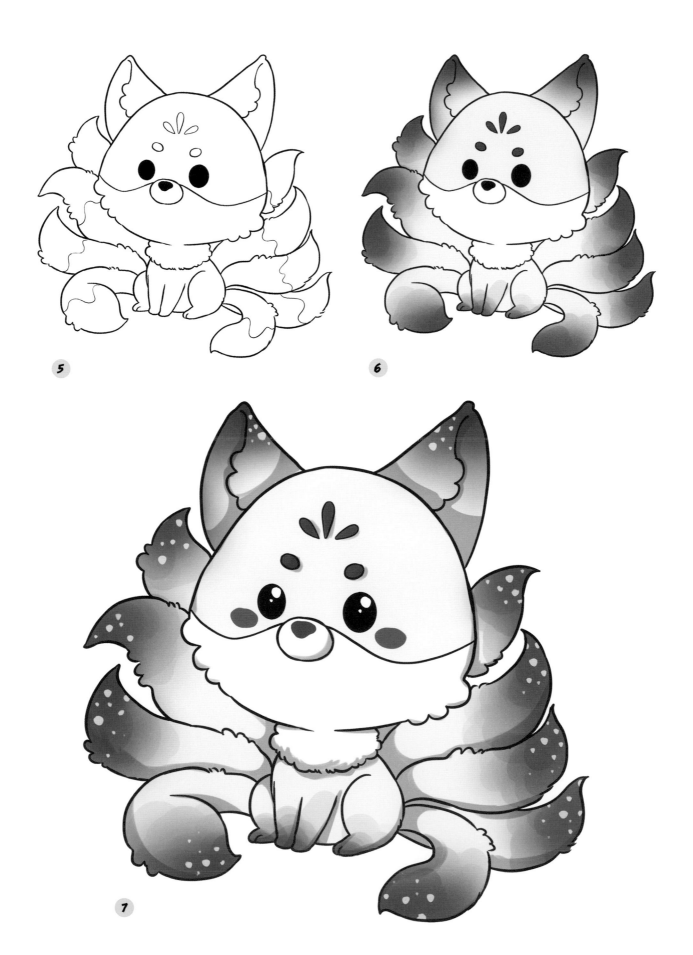

5

6

7

RAINBOW UNICORN

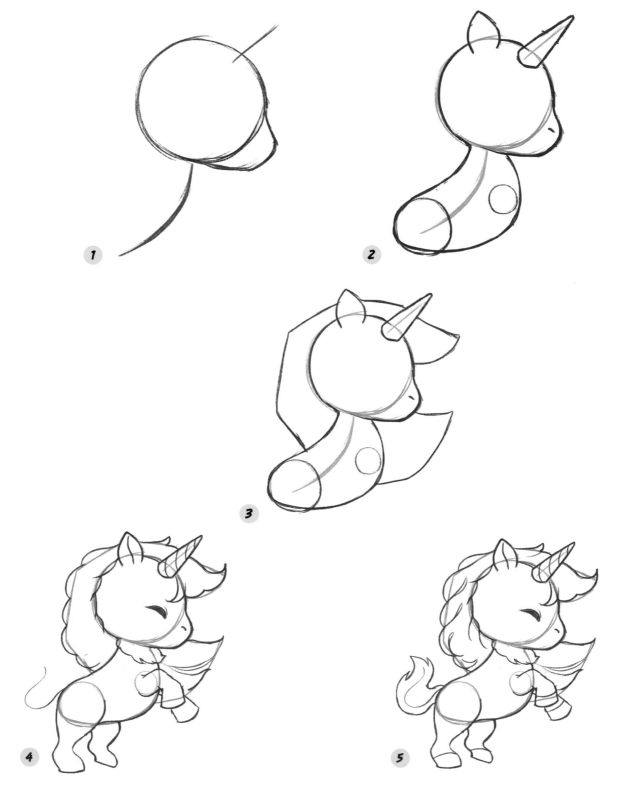

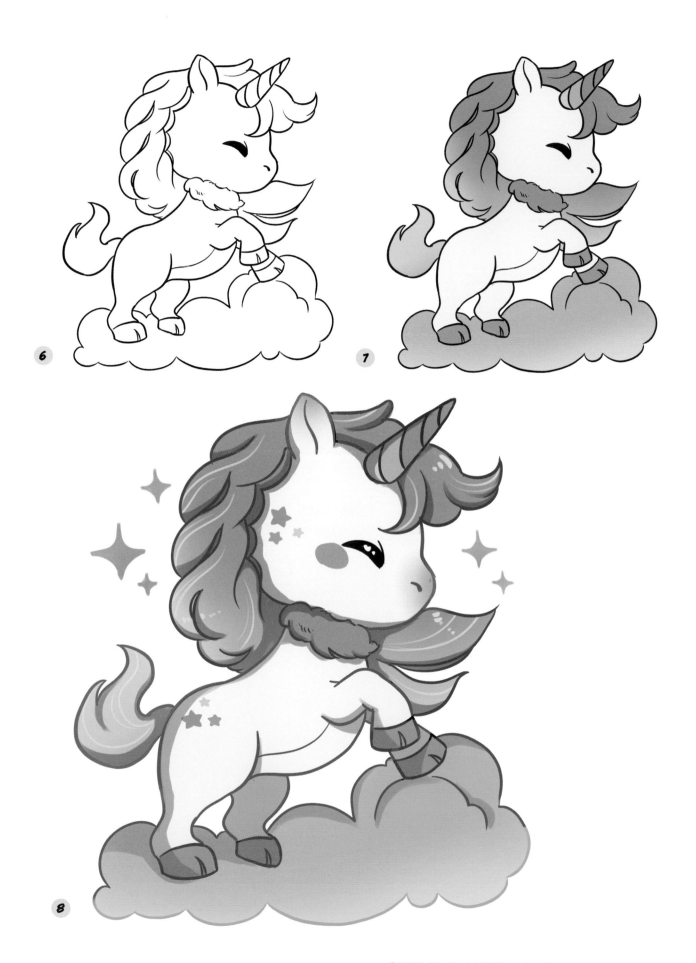

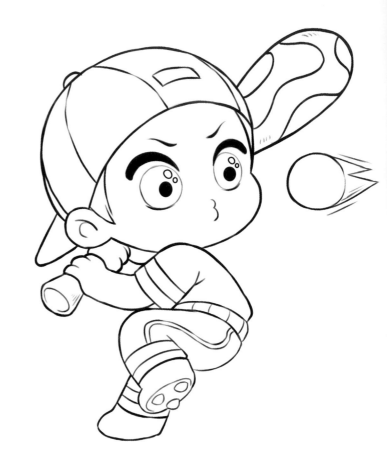
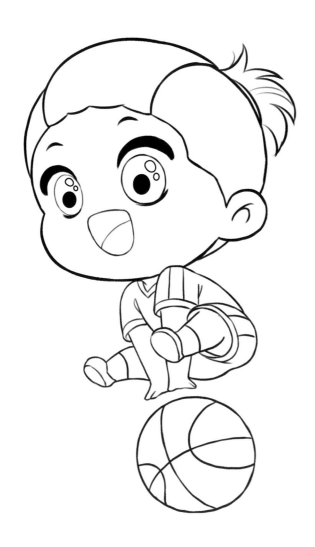
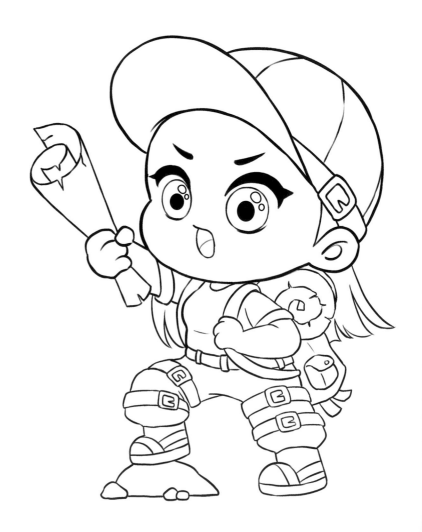

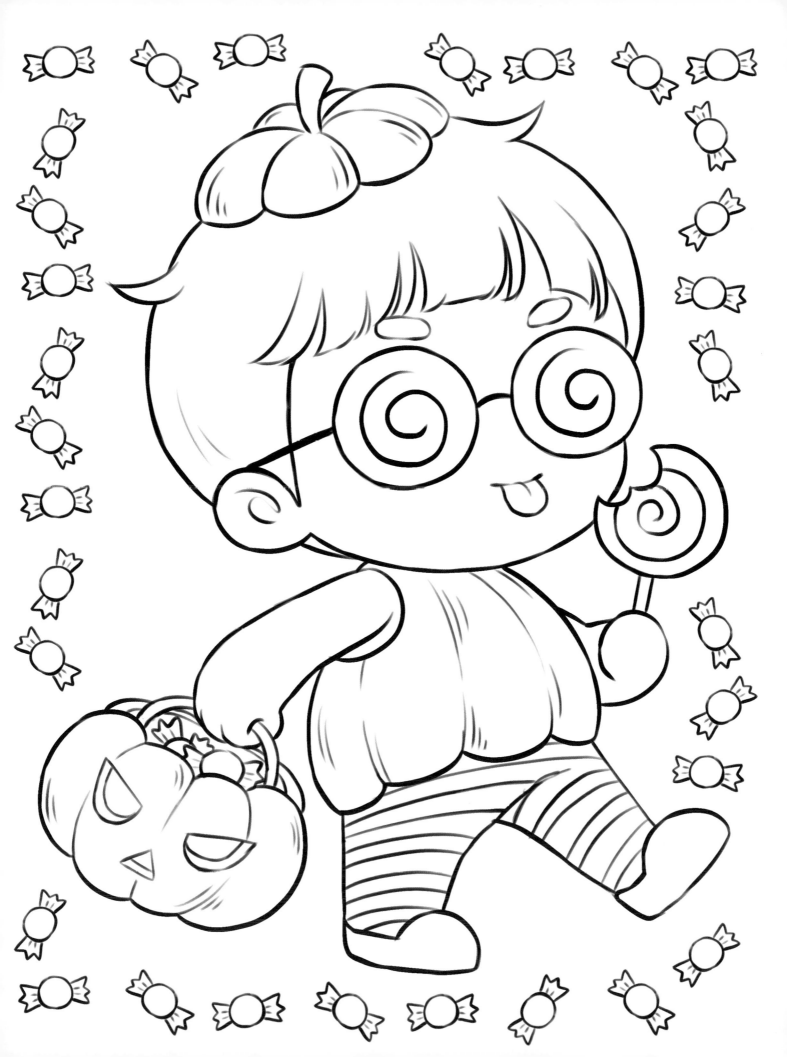

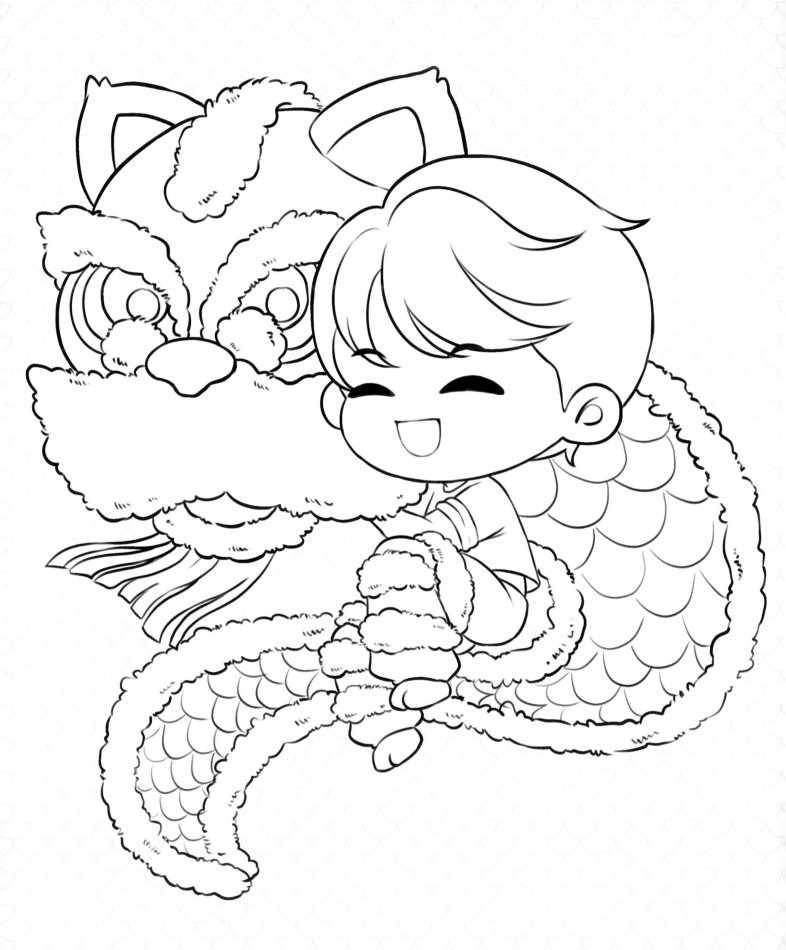

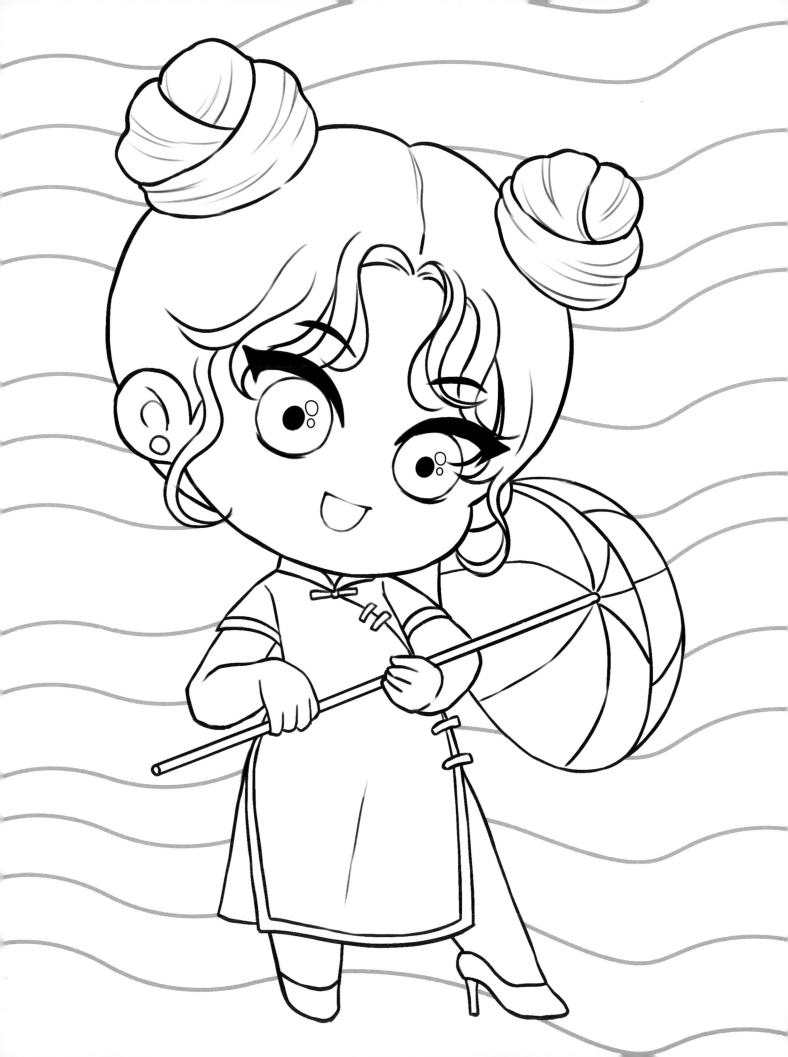

ABOUT THE AUTHOR

Chibi artist **Thao Vy** (a.k.a. **Piuuvy**) creates K-pop fan art, anime, and manga characters and private commissioned portraits and icons. She is based in Vietnam. To see more of her work, visit her on Instagram and Twitter @piuuvy.

Quarto.com

First Published in 2023 by Quarry Books, an imprint of The Quarto Group,
100 Cummings Center, Suite 265-D, Beverly, MA 01915, USA.
T (978) 282-9590 F (978) 283-2742

Quarry Books titles are also available at discount for retail, wholesale, promotional, and bulk purchase. For details, contact the Special Sales Manager by email at specialsales@quarto.com or by mail at The Quarto Group, Attn: Special Sales Manager, 100 Cummings Center, Suite 265-D, Beverly, MA 01915, USA.

12 11 10 9 8 7 6 5 4 3

ISBN: 978-0-7603-8141-0

Digital edition published in 2023
eISBN: 978-0-7603-8142-7

Library of Congress Control Number: 2022951248

Design: Megan Jones Design
Page Layout: Megan Jones Design
Illustration: Piuuvy

Printed in the United States